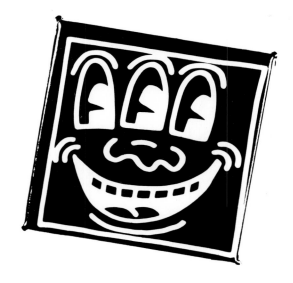

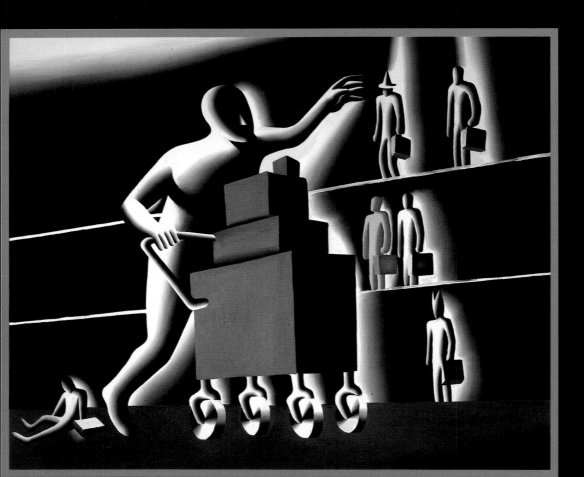

NEW, USED & IMPROVED
ART FOR THE 80'S

Peter Frank

Michael McKenzie

Abbeville Press
New York

Editor: Sharon Gallagher
Designer: Pamela Ahern
Consultant: Stephen Neumann
Production Manager: Dana Cole

Front Cover: Ronnie Cutrone, *Rayon Rabbit*, 1984, acrylic on Steven Sprouse Stretch Fabric, 56½ x 46″

Back Cover: David Wojnarowicz, *Untitled*, 1985, mixed media on paper, 15 x 8 x 13½″

Frontispiece: Keith Haring, from a lapel button

Title Page: Mark Kostabi, *Odd Man In*, 1985, oil on canvas, 60 x 72″

Library of Congress Cataloging-in-Publication Data

Frank, Peter, 1950–
 New, used, and improved.

 Bibliography: p.
 Includes index.
 1. Art, American—New York (N.Y.) 2. Art, Modern—20th century—New York (N.Y.) 3. Avant-garde (Aesthetics)—New York (N.Y.)—History—20th century. 4. New York (N.Y.)—Popular Culture.
 I. McKenzie, Michael. II. Title.
 N6535.N5F65 1987 709′.747′1 86-32273
 ISBN 0-89659-650-8

Printed and bound by Toppan Printing Co., Ltd., Japan. First edition.

CONTENTS

RONNIE CUTRONE
Running Around Like a Chicken
Without a Godhead, 1985
Acrylic and enamel spray paint
on paper mounted on canvas,
84 × 54"

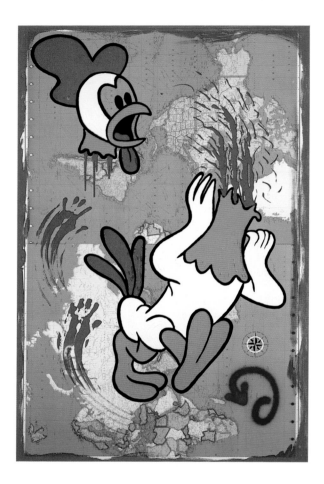

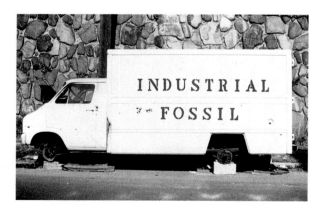

JOHN FECKNER
Industrial Fossil
Stencil on truck

INTRO

The art world isn't what it used to be. After a century of constant and often revolutionary change in culture and its artifacts, such a statement seems all too obvious. But it isn't. In the last decade, fine art has gained more public visibility than ever before. The proliferation of new galleries and museums all over America testifies to this. The clearest indication of art's heightened social presence, however, is the growing frequency with which art and artists appear in print and electronic media—not just in the newspaper reviews and the art magazines, but in gossip columns, on news broadcasts, and even in advertising campaigns.

What we are witnessing is the first generation of American artists weaned on television, artists who are taking their work back to, and through, the mass media from which it has been drawn. Artists' use of and reference to the mass media has created a cycle of aesthetic discourse that makes commerciality, long the stick with which artists feared to be flogged, a new measure for success.

The issue of art as mass-media icon, whether as concept or as product, is among the most vital questions in American art today. Few other aesthetic concerns now confront those who create works of art in any medium with the daunting and multi-faceted challenges that the promise—or threat—of media exposure and interaction present. In the past, even a past as near as ten years ago, the vital functions of 'fine art' and 'commercial art' maintained perceptible distinctions between the two, even at the moment of the work's conception. As the goals of 'fine' and 'mass' art began to encroach on each other, those distinctions blurred. Major museums now frequently exhibit the work of living architects and designers, while prominent artists affix their names and apply their talents to commercial products. The values that were

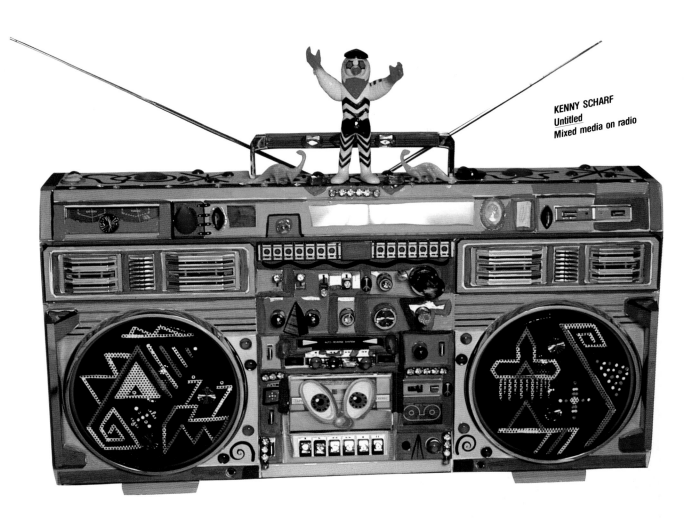

traditionally used to distinguish fine art from graphic art, commercial art, or even advertising—values such as originality, scarcity, timelessness—can seem negligible, inappropriate, even obsolete when applied to the artwork now dominating the New York scene.

Is this good news, or is it just so much disgraceful hype? On the one hand, media ballyhoo and subsequent commercial developments have allowed many young artists to

derive a substantial living from the sale of the work. If one believes that art is important, that good art contributes favorably to the human condition, then it would seem cruel to deprive a hard-working, gifted artist of the financial rewards enjoyed by successful doctors, lawyers, athletes, business executives, or any other talented professionals. On the other hand, is the art that responds to such reward good art? We play havoc with our basic cultural values and needs if we go too far in motivating artists with money—much too far if, indeed, we are churning out legions of artists who create their art not in answer to an inner drive but in response to an outer demand. The line between a market for art and art for a market blurs all too readily, making the questions of how artists deal with the media and the markets provided by the media that much more crucial.

Nowhere are these questions more pronounced than in New York. This is inevitable, as New York is America's media and advertising capital. And since the New York art scene —a scene comprised not just of New Yorkers but of artists from around the globe who have elected to make or at least to market their work from a New York base—is the primary focus

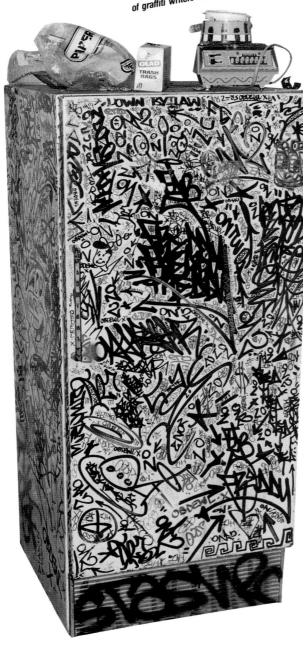

The refrigerator at the Fun Gallery shows signs of the times—"tags" of graffiti writers and artists.

compelled us to highlight prominent issues and individuals in recent New York art, we have concentrated as well on some lesser-known figures and developments, figures and developments we believe to be aesthetically as well as socially germane to the issue of art's mass-mediation.

In researching and writing this book we conducted some one hundred and thirty interviews and visited myriad galleries and studios. It is not our intention to forge these observations into some generational manifesto or polemic for selling the reader on any critical claims. We want simply to tell the story of an art community that has thrived both in the marketplace and in the media. Because the artists of this new generation—or, more accurately, generations—have embarked on such widely divergent paths to their aesthetic destinations, it was imperative that our approach to the book address these differences. To accomplish this, the book is divided into nine chapters, each providing a different access to the New York artworld. The highways and byways wend through galleries, museums, alternative spaces, artists' studios, theaters, nightclubs, and all manner of public, and not-so-public, places.

The choice of artists and tendencies is, of course, a matter of debate, and has been so between us no less than amongst any observer-participants in the scene. In producing this volume we have spent long hours debating the value of various individual talents and movements. Each of us has argued the importance of particular developments, the accomplishments of particular artists, and the appropriateness of those artists to those developments. The perceptions and enthusiasms of

of this new media attention, we have focused this book on that scene. By examining the New York art world, concentrating on the period 1978–1987, we have taken the opportunity to observe this phenomenon at close range. Such close range may not afford the luxury of critical distance; but it does allow for a direct, immediate encounter with the energy, insight, and ambition that is driving art into previously foreign social realms.

As with any successful, commercially driven milieu, the New York scene of today is a breeding ground for venality and stupidity as much as for grace and intelligence. Many of the art forms and artists that have been receiving attention in New York may well enjoy that attention for reasons other than pure merit. Although the journalistic bent of this book has

8

MIKE BIDLO
Nose Job, 1984
Acrylic on canvas, 72 × 100"

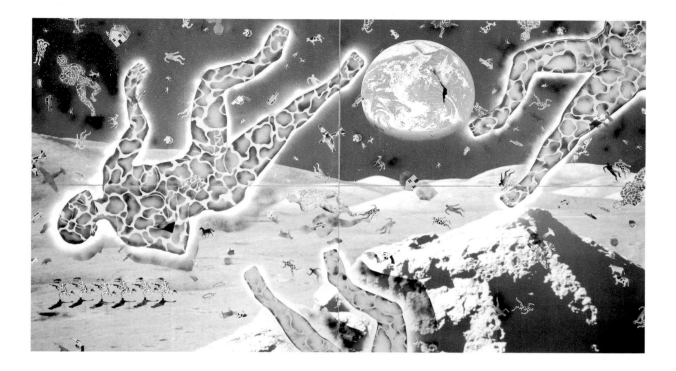

one of us have not always been the perceptions and enthusiasms of the other. But we respect each other's point of view enough to have willingly combined our divergent criteria and experiences into a report on New York art that, while obviously not all-encompassing, provides a sense of its breadth and substance.

Despite the book's subtitle "Art for the 80's," we have elected to begin in the late 1970s. We did so because we saw that the seeds for current artistic genres were sown, and were even beginning to sprout, in the several years before the decade turned. Despite the fact that this period also saw the first efflorescence of "neo-Expressionism," we decided not to discuss the work of Eric Fischl, David Salle, Julian Schnabel, Susan Rothenberg, or other New York practitioners of the neo-Expressionist style. The aesthetic strategies motivating this style are distinctly modernist, emphasizing painterliness and personal expression, as opposed to the post-modernist emphasis on mass-media pictorality which immediately followed neo-Expressionism into the limelight. This total change in aesthetic concern, this emphasis on *picture-making*, which now in 1987 is still engaging the skills and intellects of many of today's most substantial artists, defines the focus and scope of this book.

Thanks largely to the public accessibility that such picture-making affords these artists, we enter—willingly or otherwise—the era of the "art star." Time was when the kind of mass exposure provoked by the public antics of a Salvador Dali or shrewd marketing of an Andrew Wyeth were shunned as hallmarks of aesthetic superficiality and irrelevance. But with the Pop Artists—most especially with the art and persona of Andy Warhol—popular exposure became support rather than substitution for art world attention.

Although New York has been the first test market for this "art star" concept, we have noticed the trend manifesting itself in other urban centers, both in America and out. This is due in no small part to the increasing acceptance of the new kinds of mass-media-oriented art approaches which this book describes. By documenting these new artistic developments and their wider social ramifications as they emerge and evolve, we hope to provide the reader-observer with a sense of the sources and relative significance of these new developments. This book is not about the past, about the way it was and has been, but about the present, the way it has become and is becoming. *New, Used & Improved* concerns the chapter of art history we are all still living— and we all still have the opportunity to affect.

9

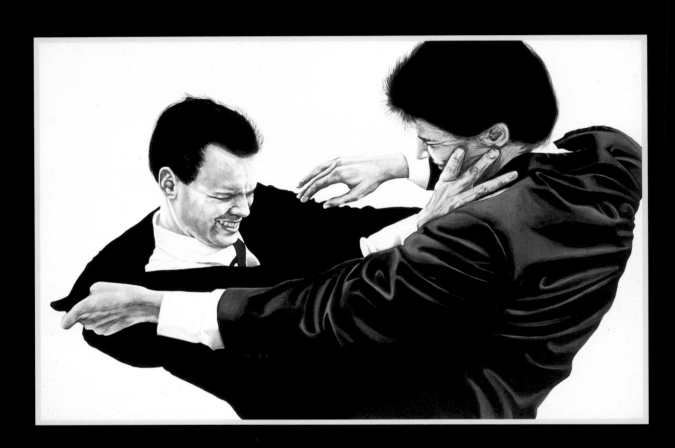

The intensity and violence of city
life, especially New York nightlife,
pervades Robert Longo's images.
The cinematic feel of his huge,
massively powerful mixed-media
artworks indicates another of their
sources: the movies.

ROBERT LONGO
Untitled, 1981
Mixed media on paper, 60 x 96″

PICTURES

While rock stars and their Hollywood counterparts dominated the media during the 1970s, artists were, by and large, serious, retiring, emphatically unglamorous nonpersonalities—excepting, of course, Andy Warhol, a curious antipersonality who made an attention-getting asset out of his blank aloofness. It was the Me Decade, yet a "big" opening for a young painter, poet, or performance artist translated into little more than fifty friends and a small review. Artists of the Baby Boom generation, fresh out of school and with high hopes for dazzling a mass audience with their creative skills, found themselves creating in and for an isolated art community. Communication between the art world and the real world was stymied by what artist Ronnie Cutrone, Warhol's studio assistant for fifteen years, calls "art babble, that strange language they teach you in art schools." Let down by the constricted horizons of the '70s art world, many visual artists began turning to other media, particularly music, in hopes of reaching the mass-media audience that they had laughed with, cried with, rocked with, and been part of since infancy.

Among them was an artist named Robert Longo, who complemented the serious business of art by moonlighting with his own band, Menthol Wars. At the time he moved to New York, recalls Longo, "I thought that suc-

11

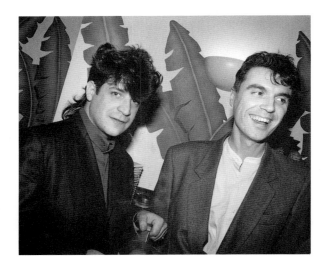

cess meant you got a gallery, they gave you a one-thousand-dollar-a-month stipend because they had integrity, and you got to sleep with art students when you gave lectures at art schools. Selling art never entered my mind." When Longo wound up an international success, it was thanks to his art, not his music. But that was later, in the '80s.

In the late '70s, the Punk and New Wave rock scenes, to which many young visual artists applied their talents, attracted endless adoration from art circles, although the rockers themselves did not solicit these endorsements. "Using the word 'art' tends to scare people away," David Byrne told *ARTnews* when asked if he considered his band art. Rock music, both as sound and as lifestyle, had the same allure for Longo's post-protest generation as it had had for that generation's activist older siblings. For the younger set, however, the music and the personalities were rallying points not for a common purpose but simply for a common sensibility. After the fall—the fall of Vietnam, the fall of Nixon, the fall of 1976 that saw the election of Jimmy Carter—all that was left was a free-floating anomie, an unfocused irritation at the narcissism into which the rest of America had fallen. There was nothing left to protest except disco. Thus was the immediate appeal of aggressively ugly, too complex, or anticomplex music.

By 1978, the downtown music scene had produced four homegrown heroes with international reputations: Blondie's Deborah Harry, Joey Ramone, Patti Smith, and David Byrne. Smith, the darling of the downtown poetry scene before she crossed over into music, had attracted journalists—fellow writers after all—from the start, while the Ramones' leather jacket gimmick and Harry's blonde bombshell act offered visual statements almost as loud as the music. Byrne, along with Laurie Anderson, painter Walter Stedding, and others, won favor for creating what is now tagged the "art band." New Wave was "it," and music was calling the tune, but art was more and more frequently sitting in.

As the scene spread out, New Wave got artier, Punks cloned in the East Village, the sicker became the better, and the tide was ready to turn. In the late '60s, rock music had served the ulterior purpose of criticizing society, and visual art had served only its own lofty aesthetic ideals. By the late '70s, however, the rock scene had turned in on itself while

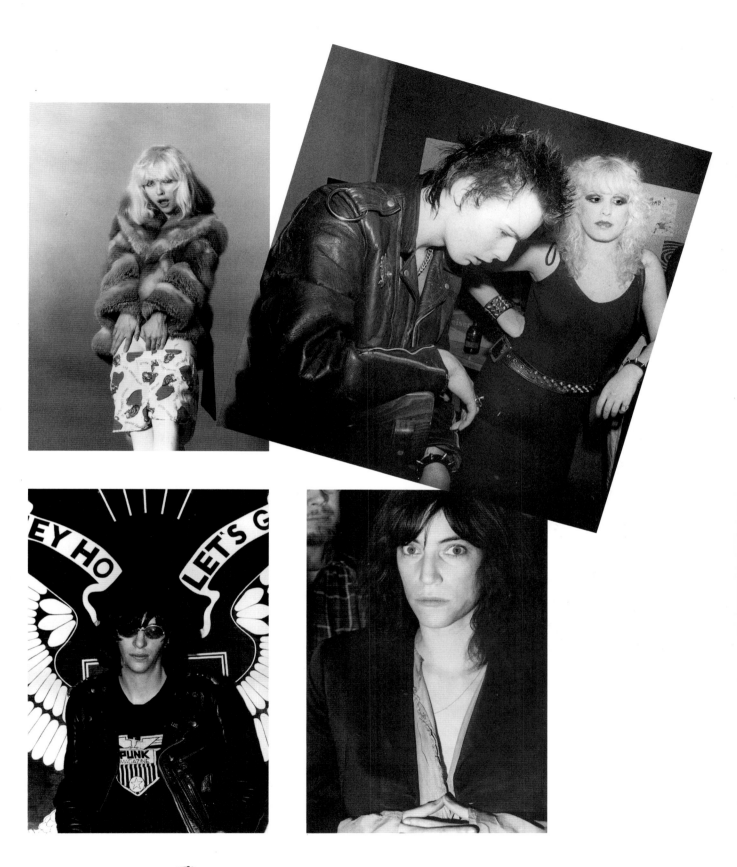

The downtown stars of the 1970s
were the rock musicians who at-
tracted the media with loud noise,
outrageous lyrics, and punk life-
styles. As their New Wave crested,
the '80s art revolution was already
building. Clockwise from top left:
Debbie Harry (Blondie), Sid Vicious
and Nancy Spungeon, Patti Smith,
Joey Ramone.

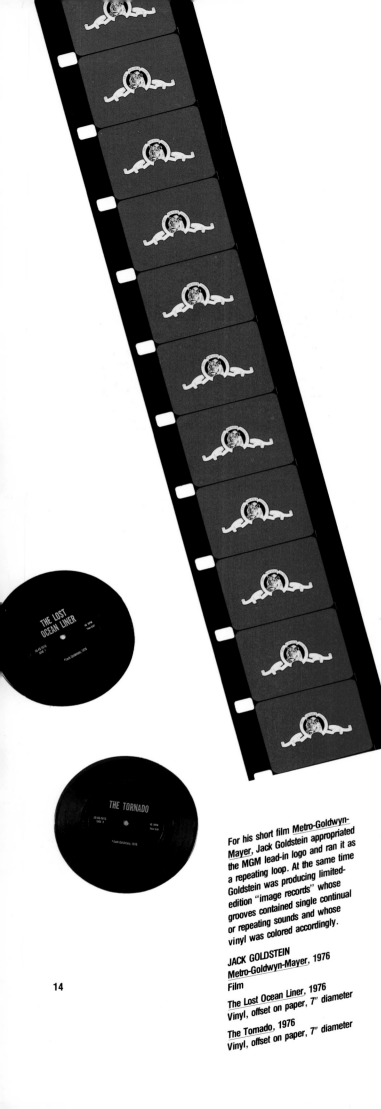

For his short film Metro-Goldwyn-Mayer, Jack Goldstein appropriated the MGM lead-in logo and ran it as a repeating loop. At the same time Goldstein was producing limited-edition "image records" whose grooves contained single continual or repeating sounds and whose vinyl was colored accordingly.

JACK GOLDSTEIN
Metro-Goldwyn-Mayer, 1976
Film
The Lost Ocean Liner, 1976
Vinyl, offset on paper, 7" diameter
The Tornado, 1976
Vinyl, offset on paper, 7" diameter

14

the visual art scene was beginning to reach out toward a larger audience. Of course, the lyrics of many Punk songs and the defiant postures struck by their singers were aimed at society at large, but the politically protestant attitudes expressed by the British Punk groups had been replaced on American soil with the slyly subversive inward turn of Devo's robotism, the humorously self-conscious nostalgia of the B-52s, the street-tough alienation of the Ramones, and, ironically, the art-school intricacy of the Talking Heads. Meanwhile, artists like Longo had begun a knowing and highly visual societal critique, equally sly but turned decidedly outward. It was far from easy access, but it was the closest art had come to mass appeal since Pop.

Longo was plugged into the music scene, but unlike peers who had traded in brush for electric guitar, he remained an artist and transmitted the New Wave energy back into his artwork. And unlike the group of young artists who had gained fame just before him—David Salle, Julian Schnabel, Eric Fischl, and the other Neo-Expressionists—Longo took culture at large as a theme and New York nightlife as a style. This formula was a given on the rock scene. But in Longo's hands it produced a body of artwork that united a coterie of disaffected cultural camps, including the more artistically skewed rockers and the avant-garde art world.

Even before he stepped onto the New York scene, Longo was fascinated by the persuasive power wielded by mass-media imagery. His earliest exhibited work, the small wall reliefs he fabricated while a graduate student in Buffalo, consists of stark, isolated images. In most cases, only a real film buff could identify them as stills from particular movie scenes, since Longo purposely chose esoteric cinema figures instead of the media icons that appealed to Warhol. Save for this identification, Longo's work seemed to be part of the "New Image" movement revitalizing painting and sculpture at the time. New Image painting, as practiced by New York artists like Robert Moskowitz and Susan Rothenberg, depicted recognizable forms, rendered realistically or diagrammatically, and isolated from any normal or abnormal context. This image-oriented painting had come down from Magritte via Pop Art, but it had its theoretical source in a relatively new group of philosophies that was emphasizing the contextual nature of identity. A keen observer of new art and an avid movie

Jack Goldstein's images of aerial battle and air-to-ground bombardment caused controversy, as they were seen to glorify modern warfare. They were not initially understood as a didactic demonstration of the distance between image, especially "artful" image, and reality.

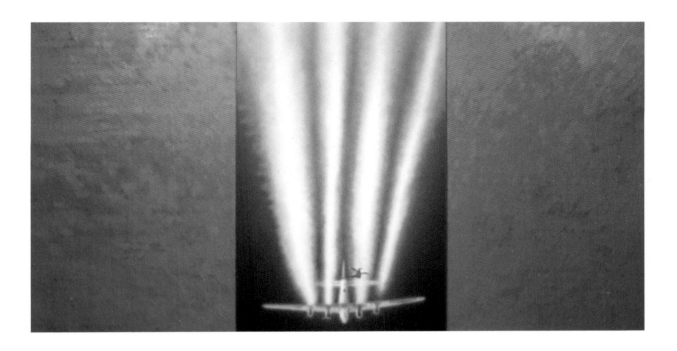

JACK GOLDSTEIN
<u>Untitled</u>, 1980
Oil and acrylic on canvas, 96 x 180″

<u>Untitled</u>, 1980
Oil and acrylic on canvas, 72 x 96″

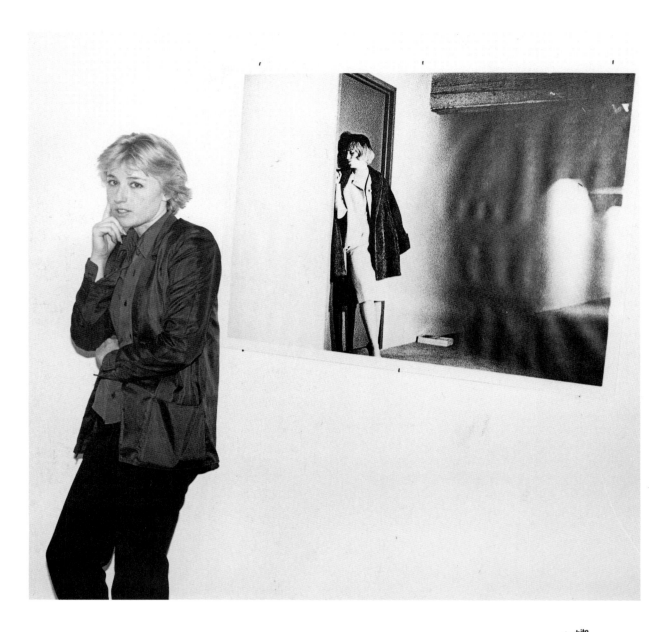

Sherman's early black-and-white photographs deliberately resembled stills from movies (especially European pictures) of the 1950s and '60s—with her invariably starring in the lead. Here Cindy Sherman poses with one of her pictures of herself posing.

enthusiast, Longo combined his passions in these tightly made painted reliefs.

Hip to the newest wrinkles in art, Longo helped found an alternative space in Buffalo in order to move those wrinkles up his way. With this funky exhibition and performance space, called Hallwalls, Longo and his companions devised a way to bring the Big Apple up to SnowHo and to haul in grant funds in the process. Longo's companions included painters Michael Zwack and Charles Clough, who, like Longo, were manipulating isolated images. Cindy Sherman was there as well and had her own way of paying homage to the silver screen. Sherman would stage scenes in front of a still camera, scenes that exuded the dated familiarity and alluring, ever-pregnant incompleteness of movie publicity stills. Even then, the now-famous Sherman masqueraded deftly as a wide range of film femmes and occasionally hommes.

By the time Longo, with Sherman, moved down to the city in mid-1977, he had become a veteran grant getter and art-event organizer, and his reputation had preceded him. Indeed, he worked for a long while as a curator at The Kitchen, SoHo's premier performance space. But Longo and his fellow Hallwallers had also come into contact with a few other artists who were taking New Image painting a step further.

Closest to Longo's and Sherman's cinemaphilic approach was Jack Goldstein, appropriately enough a product of the California Institute of the Arts, the experimental, multidisciplinary school near Los Angeles that had been set up in cooperation with the Walt Disney studios. Goldstein not only produced pictures derived from photography and film, he also made films himself. His short film pieces displayed recognizable motifs from the movies in brief but entrancing repetition. In *Metro-Goldwyn-Mayer*, for example, he had the MGM lion comically bobbing back and forth on a loop, emitting a symmetrical pattern of roars and gurgles. Goldstein also produced limited-edition records, each containing a single sound or combination of sounds that, in isolation and extension, took on the hypno-iconic quality of sonic "images."

In the fall of 1977, Longo and Goldstein were included in the landmark five-person exhibition entitled simply *Pictures*. Assembled by critic Douglas Crimp, the show was held at Artists Space, New York's adventurous alternative exhibition hall—Laurie Anderson and Jonathan Borofsky had first exhibited there—

CINDY SHERMAN
Untitled Film Still no. 29, 1977
Photograph, 8 x 10"
Untitled Film Still no. 50, 1977
Photograph, 8 x 10"
Untitled Film Still no. 3, 1977
Photograph, 30 x 40"

Sherman's work in the '80s has shifted to large-scale color prints, and her content has expanded to include a wide variety of cinematic clichés. Horror films, science fiction and fantasy, and other special effects-laden spectacles inform the newer images.

CINDY SHERMAN
Untitled no. 79, 1980
Color photograph, 20 x 24"

Untitled no. 112, 1980
Color photograph, 45 x 30"

Untitled no. 118, 1983
Color photograph, 80¾ x 56¾"

Untitled no. 150, 1985
Color photograph, 49½ x 66¾"

Untitled no. 136, 1982
Color photograph, 20 x 16"

Longo's earliest exhibited works were painted aluminum reliefs of figures, often taken from his favorite movies. That melodramatic sense continued over into his early-'80s "Men in the Cities" imagery, in more small reliefs, in large drawings and paintings, and even in performance.

ROBERT LONGO
American Soldier, 1977
Enamel on cast aluminum,
28 x 16 x 5"

and Hallwalls' downstate sister. *Pictures* hit a nerve among the downtown scenemakers. Still wary of the traditional paint-on-canvas approach of the New Image painters, younger artists found the possibilities of multi-media work proposed by the *Pictures* artists—who painted, drew, sculpted, made video, made movies, and even made books and records—more appropriate to their own mass-media fixations. In Longo's larger-than-life drawings and Goldstein's film shorts, the art world encountered the next wave of visual artists, a generation that had grown up on popular mass culture—and liked it.

Popular culture had been the subtext—actually, the *pretext*—for the work of the Pop artists a generation earlier. But the Pop artists had not looked at the same things in the same way. They had taken a wry delight in the fatuous content and unartful forms of advertising and entertainment programming, whether televised, printed, or simply hung on billboards, and their art had been a kind of gee-whiz celebration of such silly stuff. For them, the last generation that remembered life B.T.V., television had been something special, even exotic, an obscure object of desire. They could recall the day the Motorola console was wheeled into the house. Their kid brothers and sisters, however, don't understand the big deal. Never mind the knobs and funny scan lines, they wanna watch the Flintstones!

For the next wave of Neo-Pop artists, led by Longo, the nature of television is less interesting than the nature of its contents. This generation has a different sense of imagery, even information, one framed since infancy by a box sitting in the living room. This single source of theater, news, and advertising has lulled most Baby Boomers into a quasi-catatonic state from which most, as adults, still awake only long enough to make or spend money. This media reality, however, has proved to be fertile soil for the artists of that generation, to whom the various media icons convey a universal significance. These artists pervert, subvert, and convert the images that have come at them almost from birth, whether from game shows, soap operas, Saturday morning cartoons, late-night movies, mass-circulation magazines, or even art books to which these artists, as kids, fled to escape teleprison.

Like their forebears, the Neo-Popsters modify these provocative pictures, imposing symbols, consumer goods, and corporate logos

by removing them from their original contexts and changing their original scales. They do so, however, not to enhance their aesthetic value or shared social experience, as the Pop artists did, but to gain a critical distance from them. In the terms of the currently fashionable social philosophy, they "deconstruct" these images in order to neutralize their original influence on our perception of the world. Unlike the original Pop artists, who were most intrigued and influenced by the formal impact of advertising and communications media, the Neo-Pop artists undercut the function of mass-media imagery without enhancing the design. They might conjoin or superimpose disparate images in order to enhance sensory impact or to posit an oblique critique of the images' contents or original contexts; they might shroud the supposedly obvious identity of images in mystery, or invent images that are oddly familiar; they might even copy images as exactly as possible—if only to demonstrate the inexactitude of such copying. But they are little concerned with making nice new images out of not-so-nice, not-so-new ones. Some of the Neo-Pop artists—"image appropriators," as their critical supporters dub them—appropriate imagery in order to loosen the thrall in which mass-media icons hold us. Others appropriate not specific images, but styles or modes of imagery, visual vocabularies that we recognize immediately but that now convey unanticipated, even inappropriate, messages. Tension results between the nature of images as more or less pleasant optical designs and their function as information— especially information created to influence opinion and action. Artistic manipulation equals critical distance; critical distance equals liberation, or even control.

With the advent of the Neo-Pop artists, art emerged from a decade of daunting diffidence and esoteric experiment, becoming more approachable and more active. Painting was back in. More accurately, *pictures* were back in. If this work gave the general public something to think about, it also, more immediately, gave them something to look at.

In 1980, Helene Winer, director of Artists Space at the time of the *Pictures* show, left that honorable but nonprofit position to team up with Castelli Gallery veteran Janelle Reiring and start a gallery they called Metro Pictures. As its name proclaimed, the gallery was designed to represent—indeed, to contextualize—media-picture artists like Longo,

Longo has called himself "the anti-Christ of media, coming back at the culture that created me."

ROBERT LONGO
Songs of Silent Running, no. 5, 1981
Cast aluminum, 26½ x 20 x 4"

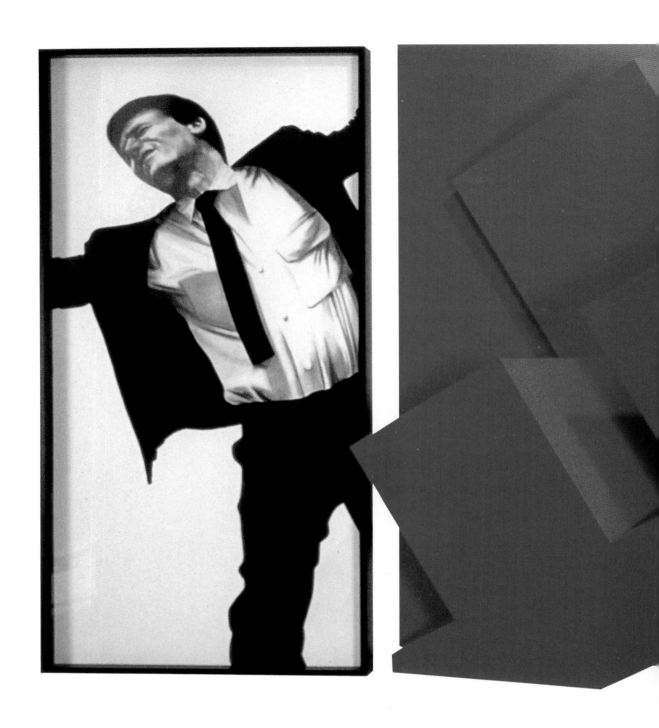

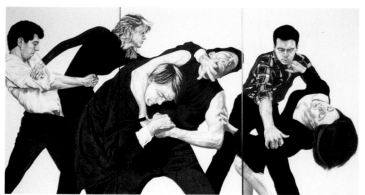

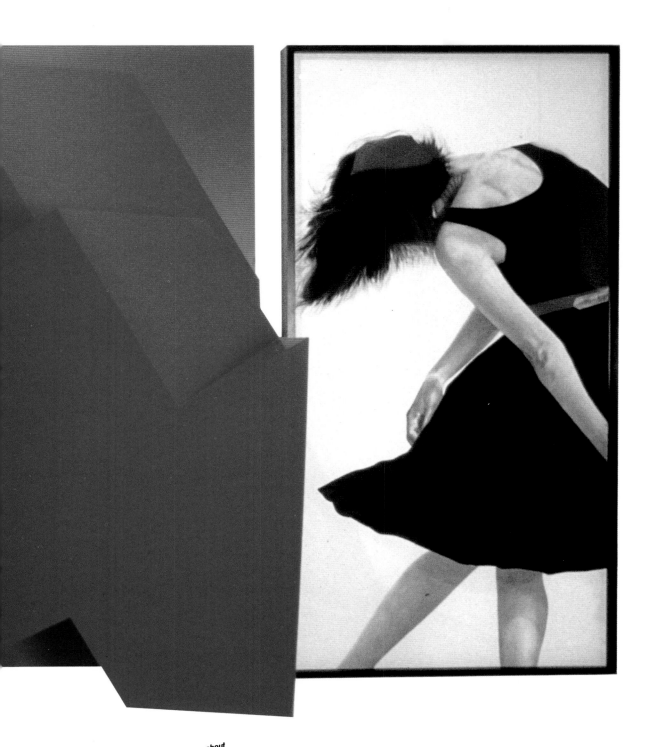

"I used to think that art was about not compromising," Longo says, "but I finally realized that compromising is an art in itself."

ROBERT LONGO
Untitled, 1982–84
Mixed media, 96 x 184 x 36"

Untitled (White Riot Series), 1982
Charcoal, graphite, ink on paper,
96 x 18"

"I like to walk around the studio with my guitar and play real loud," Longo admits. "It's like meditating on the meaning of art with Jimi Hendrix as the consultant. . . . I always wanted to have a Fender Stratocaster, so I invented this sculptural piece so I could buy one."

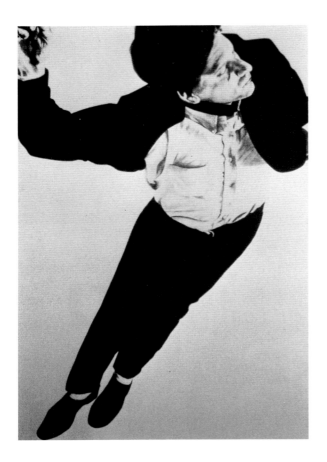

ROBERT LONGO
Untitled, 1982
Charcoal, graphite, ink on paper,
84 x 60"

Sherman, and Goldstein. Around the same time, Longo himself took a similar plunge. "One day I came home and decided that I couldn't make it working two jobs, a cabby and an artist. I went into extreme debt, over fifteen thousand dollars. But I worked full-time on my art and it all paid off."

"What I'm doing," explains Longo, "is not a rephrasing of Pop. It's a vindication of Pop, just as Pop was a vindication of Dada." Longo's point of view, part academically informed insight and part street-smart ingenuity, helps him convey his ambivalent feelings about contemporary American life. More important, however, Longo is able to admit those ambivalent feelings in the first place. He capitalizes at once on his sensual delight in modern commercial and cinematic images and on his suspicion that such sensual delight yokes him to the consumer culture. As an artist, Longo desires to be particularly free of that yoke. The danger is double for artists, he believes: the commercial world can easily coopt art, but art cannot safely coopt the commercial world. "The fucking Madison Avenue people have stolen the anger from the artists and have taught fifth-rate actors to use it to sell Coke," Longo complains. "Entertainment is supposed to be one-dimensional," he concedes. "That's cool. But art should work on several levels."

Robert Longo's media-inflected paintings, drawings, constructions and multimedia stage spectacles have become larger, more imposing, and more physically durable, but not that much more elaborate, as his work progresses. The career success that originally caught him so off-guard was in good part the result of his dealers' art-market savvy and his own. But the inherent aesthetic strengths of Longo's work, and the resonance it continues to create in the apprehension of the television generation, are the main factors that keep him in the limelight. "I've reached the point," says Longo, "where I believe my art can have enough global impact to change the world."

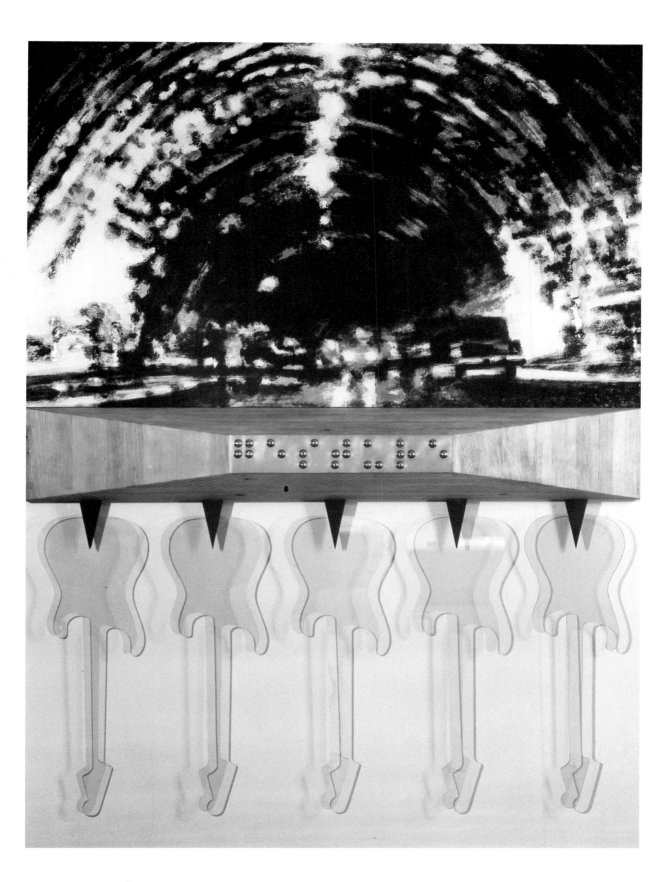

ROBERT LONGO
Untitled (Glass Guitars), 1983
Oil on aluminum, wood, brass,
glass, 101¼ x 78 x 18"

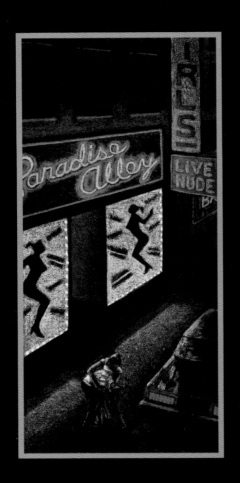

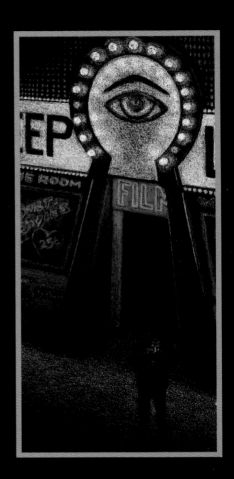

Jane Dickson's paintings and drawings capture the seedy underside of urban life with particular immediacy. The viewpoint they afford is that of a second-story window, overlooking the scenes of the crimes. In fact, Dickson and husband filmmaker Charlie Aheam live in a loft overlooking one of the worst corners in Times Square.

JANE DICKSON
Paradise Alley, 1983
Oilstick on canvas, 90 x 40"

Peep Land, 1984
Oilstick on canvas, 66⅛ x 30"

Frisking, 1983
Oilstick on canvas, 90 x 40"

COLLAB-ORATIONS

Art must change minds. The 1970s were full of artists who earnestly believed this. But the '70s were also full of artists who grew frustrated with their inability to reach out beyond the art world. The issues that concerned them did not concern the public at large, even if a growing portion of that public was attending art exhibits. And even when artists did address issues of concern to everyone—war, poverty, ecology, civil rights, feminism—they rarely found effective ways of communicating. Worse, artists were not adept at—indeed, were fearful of—breaking through the gallery and museum systems from which they sought their legitimation and support. Even the alternative spaces set up during this time to encourage experiment quickly became traditional showcases.

A new crop of artists coming to maturity in the later 1970s keenly sensed the stagnation. They began investigating conduits for their images and ideas outside SoHo's clean white rooms and the vast, grungy spaces of the alternative organizations. These artists were young, but they were savvy, good at networking, and eager to cooperate with one another to get things done. They wanted practical channels for their idealism. They set about tapping pipelines connected not to the artistic mainstream, but to the flow of all humanity, especially the flow consigned to the gutter where the hapless and the helpless, the

27

Views of the Times Square Show
(top to bottom): Rats by Christy
Rupp, an installation by Jane Sherry
and Aliha Mayer, and Tom Otter-
ness' punching bag.

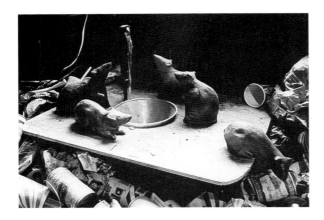

vanquished and the victimized, are washed
away in a flux of goods and not-so-goods.

Times Square was a sewer, all right, and
the waste that passed through it included the
worst trash American consumer culture had
to offer. During the month of June 1980, more
than a hundred earnest and politically mis-
chievous artists took over a four-story office
tenement at the corner of Seventh Avenue and
Forty-first Street, filling the dilapidated hall-
ways and cramped rooms of a former massage
parlor with every imaginable visual—and ver-
bal, sonic, and theatrical—assault. It was not
the first such battle these artists had waged,
but it was the biggest. After the *Times Square
Show*, the art world could not ignore the guer-
rilla tactics these artists were using to push
their messages through new and wider chan-
nels of communication.

Appearing at the turn of the decade, the
Times Square Show proved to be an effective
(if sleazy) springboard for many of the artists
and ideas that have since reshaped art. "I
went to the *Times Square Show* practically
every day," says Jeffrey Deitch, who wrote a
major article for *Art in America* on the exhibi-
tion. "If you trace the history of art in the '80s,
you will find that the show was responsible for
bringing all the elements together. It mixed
graffiti artists, feminists, political artists, and
all kinds of new people like Keith [Haring]
and Kenny [Scharf] who weren't part of any
group. It literally forged the uptown-down-
town union that has been responsible for
many of the most interesting developments in
art today."

Even before you entered, the mood of the
Times Square Show was set by carnival music
and barkers' cries broadcast into the street as
well as by the crowd of downtown hipsters,
Harlem youngsters, and local slimesters mill-
ing about the entrance and checking it all out.
Inside, the first display one encountered was a
sales desk-cum-souvenir shop, an art empor-
ium that combined the low-voltage commer-
cialism of a museum bookstore with the messy
array of gewgaws hawked in the neighbor-
hood's novelty shops. But the often daft and
occasionally sinister objects offered for sale
could be bought at no museum store or knick-
knack palace. Photocopied images, kitschy
fetishes, original sculptures bagged like dime-
store favors, artists' books produced in limited
runs of one hundred or two, ill-fitting masks
and items of adornment, privately produced
cassettes of aspiring Punk bands, posters,

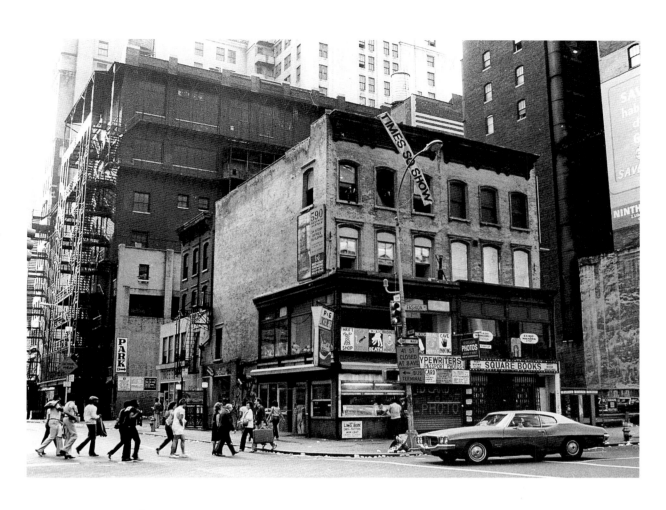

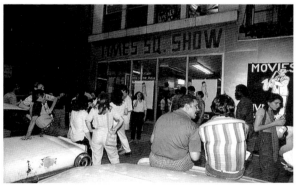

"This past June . . . the hordes of half-wild, half-crazed, and fully de-generate individuals who keep pour-ing out of the 42nd Street subway had occasion to check out a whole building full of art that was just as raw, raucous, trashy, and perhaps even as exciting as some of the more notorious attractions of the tenderloin." — Jeffrey Deitch, re-viewing the Times Square Show for Art in America, September 1980.

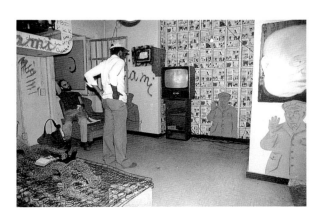

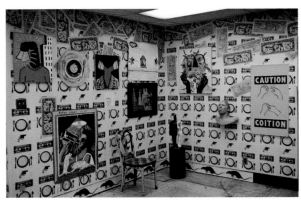

"Carnival music and hawkers' chants lured the curious toward a ramshackle four-story structure on the corner of Seventh Avenue and 41st Street covered with midway signs, banners and subway-style graffiti. A motley collection of ragged-looking and aggressively fashionable characters leaned out of the open holes that had once been windows and stood talking on the sidewalk, mixing with the street people who wandered by." —Jeffrey Deitch, reviewing the Times Square Show for Art in America, September 1980.

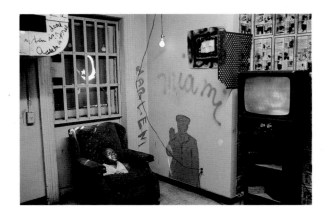

badges, T-shirts, and who knows what else were available for—well, what they looked like they ought to cost. Across the hall, filmmakers, videographers, and performance artists displayed their talents in ceaseless succession. Upstairs the visitor was treated to a visual barrage of collages, statues, sculptures, hanging objects, slapdash paintings, and even a punching bag set up for practice. It was all cheap and easy, right in line with the tone of the neighborhood.

Given the upbeat realization of this downbeat concept, and the art world's perpetual hunger for something new and raw, the *Times Square Show* hit like a dose of free-based cocaine. "It proposed not just a change in imagery, or even in structure, but also a change in intent," wrote Deitch. "Most of the art in the show had a concrete rather than an abstract purpose, be it entertainment, sexual expression, or communication of political messages." Heavy on parody, titillation, and wacko dereliction, the show was infused with a Neo-Pop Art consumer voyeurism—part Andy Warhol, part Red Grooms, and Times Square all over. It was a very mixed message, but it excited a public previously bewildered and benumbed by the esoteric concerns of the art world. The show was a forceful charge of immediate sensations that struck a nerve.

The *Times Square Show* was the work of Collaborative Projects, or, more simply, Colab, an organization that had coagulated around 1977 from a large, free-floating group of downtown artists. These artists worked in many styles, many media, and many disciplines but shared a common sense of social alienation. Most were recent products of the nation's art schools and universities, had lived through the vicissitudes of the protest years, and had come to New York with the unfocused dissatisfaction of those exhausted from winning an inspiring but taxing battle in a never-ending war. By banding together they were able to raise grant funds, organize exhibitions, share talent, labor, and equipment, and thus make art and build audiences outside the conventional art world. They were held together by Colab's "Rule C": collaborative, collective, cooperative, communal projects only.

The interaction encouraged by Colab was not simply between artists but between art and the larger urban environment, whose presence and influence the established art world habitually locked out. The largest, most auda-

cious, and most effective of these projects, the *Times Square Show,* was a surprising but logical move in a strategic series of aesthetic dislocations that took art entirely outside the geographical context of the established art world, into the drugged streets of Manhattan's Lower East Side and up to the slums of the South Bronx.

The earliest Colab exhibits and performances in TriBeCa and SoHo, potpourris tied to themes like "dogs" and "Batman," were little more than elaborate excuses for fooling around and having a good time. When Colab's venue shifted, however, to a cramped, rundown storefront at the butt end of Bleecker Street—hard by the Bowery skid row and the Punk bastion of CBGBs—the show themes got tougher too. The first called on its contributors to address *Income & Wealth*. Most of the exhibited works voiced indignation at perceived inequities in the distribution of wealth. The second Bleecker Street show, *Manifestos,* by contrast, required participants to focus on an inflammatory rhetorical device rather than an inflammatory subject. The manifestos festooning the walls took all imaginable forms and pronounced all imaginable (and some unimaginable) declarations, creating an ambience of riotous defiance.

The next major Colab event was itself defiant and potentially, if not actually, riotous. On New Year's Day, 1980, the Committee for the Real Estate Show (CRES), a Colab subgroup, opened a characteristically omnibus theme show. It was full of the expected constructions, collages, paintings, and found objects, all concerning urban real estate and, as usual, cleverly attacking the myriad injustices suggested by the theme. After *Income & Wealth* and *Manifestos,* such politically charged art came as no real surprise. And, after the unfinished lofts and that cruddy storefront, the location of the *Real Estate Show* in a two-story abandoned factory showroom on Delancey Street, in the heart of the Lower East Side, was only logical. What was not as readily anticipated was how the committee had secured the derelict building for their exhibition. They broke in.

"The city-owned storefront at 123 Delancey," reported Lehman Weichselbaum in the *East Village Eye,* "had been invaded and commandeered by CRES on December 30 after what they claim to be a year of long and frustrating campaigning to rent the property for an exhibition space from officials of the De-

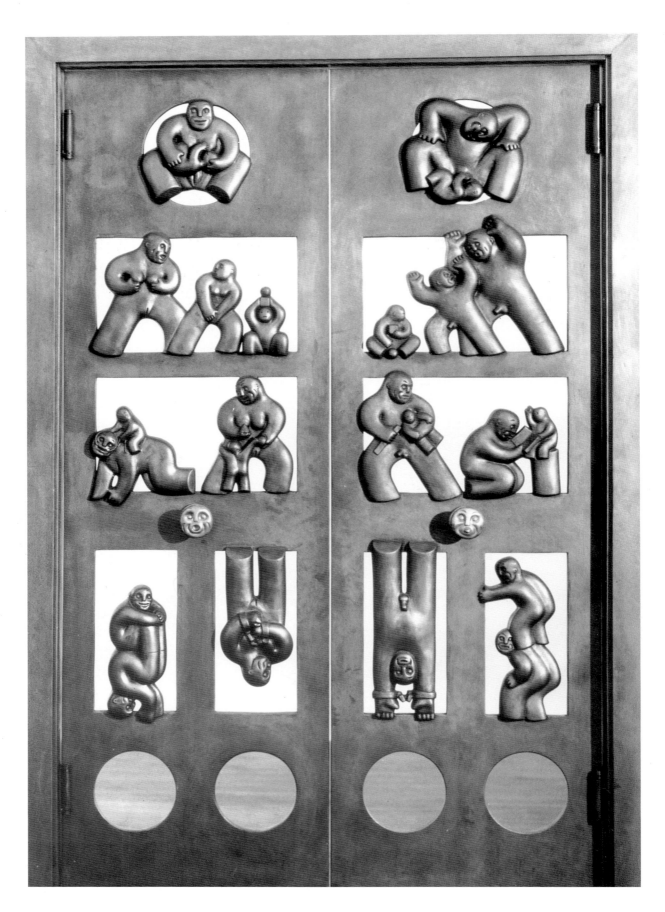

TOM OTTERNESS
The Doors, 1984
Pressed wood and bronze,
95½ x 60 x 5"

partment of Housing Preservation and Development (HPD)." For once, a Colab manifestation did not simply decry the powers and circumstances that be; it disobeyed them. And it provoked their wrath. "On the morning of January 2," continued Weichselbaum's report, "artists discovered the storefront padlocked from the inside, their work locked within. Phone calls revealed it to be the doing of HPD."

Meetings with the department ensued, to no avail. CRES held a press conference outside the locked building, and the HPD responded by emptying 123 Delancey and depositing the booty in an uptown warehouse. A compromise was finally reached (through a department official who also happened to be a TriBeCa artist), and HPD allowed CRES to occupy a former beauty salon down the street from the disputed show site. Colab used this storefront as a planning office until it secured a more workable space on nearby Rivington Street. It has remained there to this day.

Rivington is not the main thoroughfare Delancey is, but it is even more in the thick of the Lower East Side *barrio*, allowing Colab members and sympathizers a genuine and ongoing relationship with neighborhood people. Ever since its founding in the fall of 1980, ABC No Rio—a name poignantly derived from a faded Latino lawyer's sign across the street—has been the unofficial Colab headquarters and the place where, despite cramped accommodations, most of the theme performances and exhibitions that followed the month-long assault on Times Square have been mounted. *Suicide, Murder & Junk, Animals Living in Cities, Crime Show, Erotic Psyche, Extremist Show,* and *Island of Negative Utopia* are the revealing titles of typical offerings at Colab's home base. And it is perhaps because the group now has a base, and is committed to maintaining and servicing it, that none of the events Colab has sponsored since the *Times Square Show* have matched its daring, intensity, or influence.

Success may have dampened Colab's revolutionary fervor. More likely, however, Colab finally has what it wants for itself and is now doing what it wants to do for, and with, its community. Certainly the new Colab headquarters on Rivington Street are not surrounded by the fern bars and poster shops that have taken root in other erstwhile no-man's-lands. Real estate speculators may one day gentrify Manhattan's most durable slum,

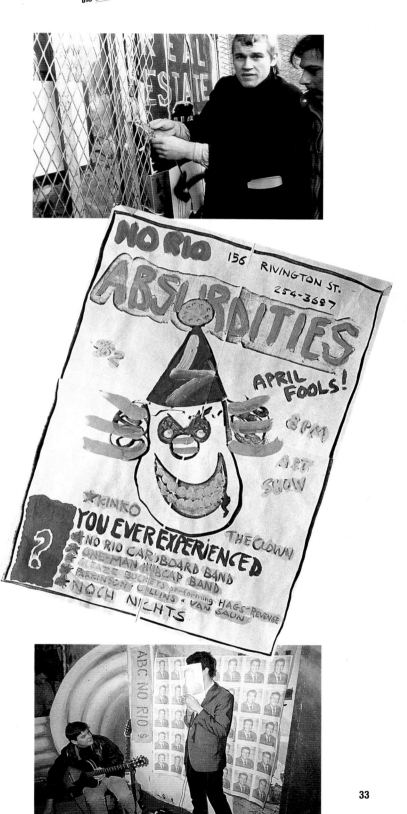

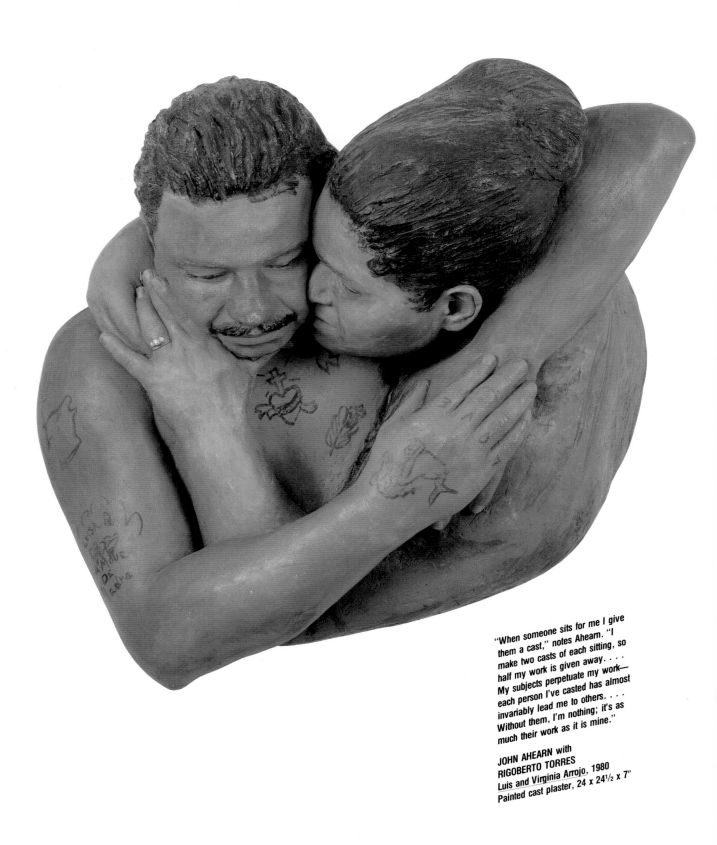

"When someone sits for me I give them a cast," notes Ahearn. "I make two casts of each sitting, so half my work is given away. . . . My subjects perpetuate my work— each person I've casted has almost invariably lead me to others. . . . Without them, I'm nothing; it's as much their work as it is mine."

JOHN AHEARN with RIGOBERTO TORRES
Luis and Virginia Arrojo, 1980
Painted cast plaster, 24 x 24½ x 7"

"I've said that I love every person I've casted, and that is the fact," says Ahearn. "The people I've casted have given me more life experiences than any art education or college could hope to. The key to my work is life—life-casting."

Luis with Bite in Forehead, 1980
Painted cast plaster, 24 x 21 x 6"

Pat, 1982
Painted cast plaster, 28½ x 16½ x 11"

Tiny, 1986
Painted cast plaster, 20 x 20 x 8"

Luis, 1986
Painted cast plaster, 20 x 20 x 5"

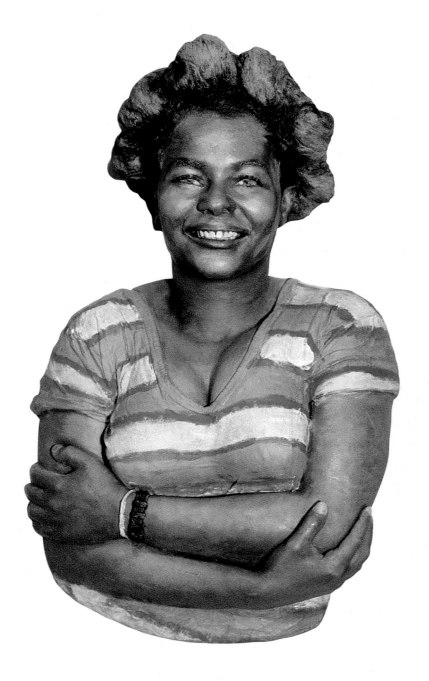

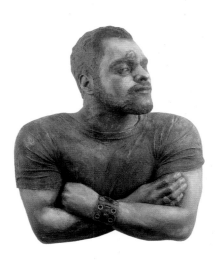

once the home of Jewish immigrants and now
known by its largely Hispanic population as
"Loisada." But the process of bulldozing bo-
degas to build boutiques will have been
impeded, not abetted, by Colab.

Colab has succeeded in showing art in a
light quite different from the track lighting of
SoHo's West Broadway. One show was closed
by city officials, probably the highest tribute
a government can pay to art, as Richard
Goldstein observed in the *Village Voice*.
Neighborhood junkies once stole found ob-
jects (including an old TV and a beat-up
Mixmaster) that artists had installed in an ex-
hibition entitled *Suburbia*. If the Colab artists
have, like all artists, tried to affect the vision of
others, they have also been affected and al-
lowed themselves to be changed by their new
situation. Where they have succeeded—most
ambitiously in Times Square and more dura-
bly on the Lower East Side—they have held an
aesthetic mirror up to their urban environ-
ment. For many in the art world, this mirror
has revealed unknown aspects of that environ-
ment. For many outside, Colab's mirror
framed an aesthetic identity.

If one Colab artist can be singled out as
exemplary—"the motor," as fellow Colabber
Stefan Eins has called him—it is John
Ahearn. It was Ahearn who talked a Times
Square real estate broker into giving an odd
group of artists the use of a building for an en-
tire month, rent-free. By that time Ahearn had
moved to the South Bronx to make sculptures
cast from the people inhabiting America's
most brutal slum. An upper-middle-class
white boy who has adapted to life in the
ghetto, John Ahearn lives and works in a
neighborhood many art world denizens are
even afraid to visit.

Ahearn's work is, among other things,
about collaboration and the many different
forms it may take. Reflecting on how artists
can—and can't—collaborate with one anoth-
er, he cites his twin brother Charlie, whose
1982 film *Wild Style* was a successful and sen-
sitive treatment of graffiti writers both as
outlaws and as artists. "In the mid-'70s my
brother and I had both gotten interested in
making eight-millimeter documentary films.
Independently and without knowledge of
what the other was doing, we both made films
on the Bowery bums, films that were nearly
identical in concept and content. Why would I
ever want to collaborate with Charlie? The
only basis for collaboration is exchange of

JOHN AHEARN with
RIGOBERTO TORRES

Youth of the South Bronx, 1981–82
Painted cast plaster
From left to right:
Duane and Al; Berenice;
Bobbie; Karen; Esther; Ciba

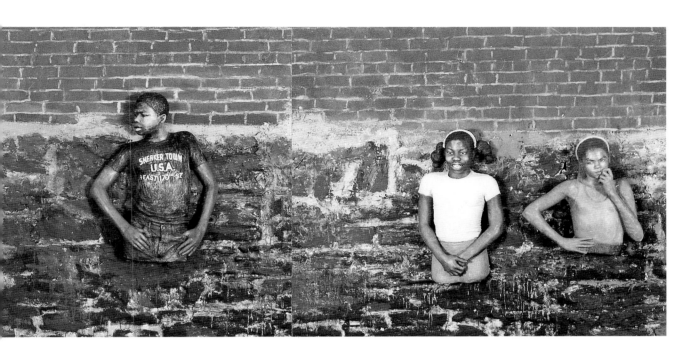

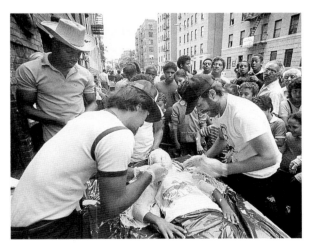

"When you're lying down to be cast," Torres observes, "it is a very spiritual trip. You can't move, and it's completely dark, so you think things about yourself that you've never thought before. Then you have the cast up on your wall and you constantly remember the experience." And, notes Ahearn, "Being under this cast is a tremendous gesture of trust." Clockwise: Walton Avenue Block Party; casting Tiny; casting at Fashion Moda Gallery.

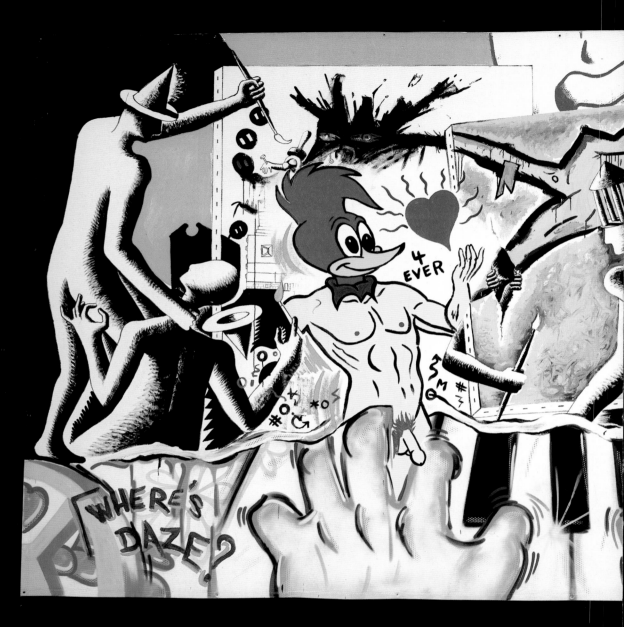

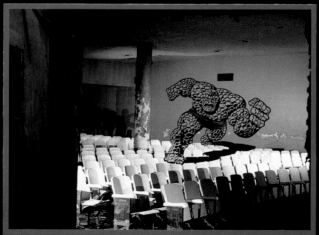

Throughout its South Bronx history, Fashion Moda has not only sponsored exhibits in its own space, but has arranged for artists to do special works at other sites, like this trompe l'oeil rendition of the comic book superhero The Thing, painted by German-born Justen Ladda in the auditorium of an abandoned school.

JUSTEN LADDA
The Thing, 1981
Tempera and latex on chairs and wall, installation at P.S. 37, the Bronx.

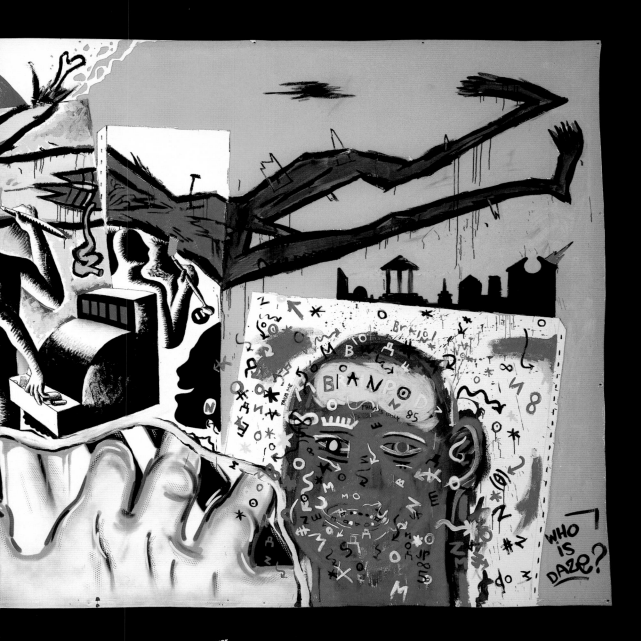

The collaborative spirit carries over
into the graffiti work sponsored by
Fashion Moda. Five artists jointly
realized this mural in an afternoon.
(A sixth, Daze, was to have partici-
pated, but called in sick. Thus the
tag, "Where's Daze?")

RONNIE CUTRONE, MARK KOSTABI,
JAMES POPPITZ, CRASH, RICK PROL
Untitled, 1985
Mixed media on canvas, 120 x 240"

REBECCA HOWLAND
The Real Estate Octopuss and Manhattan as a Dead Horse, 1983

CHRISTY RUPP
Higher Intelligence, c. 1983–84

ideas, not reconfirmation that you are right." True to his theory of collaboration, John Ahearn chose to work with someone from a background very different from his own. Rigoberto Torres, Ahearn's collaborator for half a decade (and a sculptor in his own right), brought to their teamwork the technical knowledge he had gained as an apprentice to his uncle, who cast plaster statues for churches and cemeteries. Torres's technical expertise and his familiarity with the subjects of the work make the painted casts he helped create every bit as much his handiwork as Ahearn's.

"The key to my work is life—*lifecasting*," explains Ahearn. "The people I've casted have given me more life experiences than any art education or college could ever hope to. Being under the casting material is a tremendous gesture of trust, and the people I cast *know* that they are as responsible for my work as I am, even more so. The people make my sculptures." Ahearn's straightforwardly painted and modeled casts capture much of their subjects' simple pathos and unselfconscious dignity. His work does not romanticize or celebrate his subjects as third-world slum dwellers. He simply finds these people to be especially attractive individuals whose attitudes toward themselves, each other, the environment, and his work are as open as their miens.

Ahearn makes two casts of every subject. One becomes art as the art world recognizes it, hanging perhaps on the wall of a SoHo gallery or uptown museum. The other he gives to the subject. "The people who have casts up in their apartments know that *they* made the art, that it has them in it." Ahearn's work must, in his words, "answer both to the Whitney and the South Bronx." In fact, his enormous outdoor wall sculptures have not only gained respect from the South Bronx community, they have brought a sense of self-respect to that neighborhood.

The cooperative spirit and pioneering urge of Ahearn and Colab have been percolating through New York artists for at least a decade. Establishments like Jeffrey Lewis's 112 Greene Street space, with its group-effort group shows, or Stefan Eins's 3 Mercer Street Store, with its emphasis on cheap multiple-art objects (which anticipated Colab's own A. More Store), figured significantly in the early days of SoHo, long before Colab. And it was Eins, not any central Colab committee, who with Joe Lew

headed up to the South Bronx and established
an art center that blended downtown artistic
methods with the popular forms of the *barrio*.
Fashion/Moda, a collaboration between artists
and neighborhood folks (and one of graffiti
art's breeding grounds), helped lure Colabbers
like Ahearn out of the art ghetto and into the
real one. More cautious art types also began to
venture into the Bronx's heart of darkness. By
now Fashion/Moda is a regular stop on the
itineraries of California curators, Chicago
collectors, and European cultural commissars.

But the story of collaboration and social
commitment among New York artists in the
last decade is first and foremost the story of
Colab. Colab is not a 1960s-type revolutionary
artistic commune, idealistically committed to
impossibly utopian goals. It does not aspire to
eradicate poverty, bring about fair housing, or
even halt gentrification. Its rhetoric and tac-
tics are aimed at more practical matters, at
voicing more realistic protests, at reaching
more clearly defined audiences, and generally
at exemplifying a spirit of collective action
that rewards collective accomplishment, not
egotism. Through such concrete achievement
the art of Colab does change those who see
it—and those who make it too.

John Feckner goes around New
York stenciling words and phrases
in places where they take on a
poignant or critical tone. Some-
times the extent of the criticism,
given the circumstances, can sur-
prise even the artist.

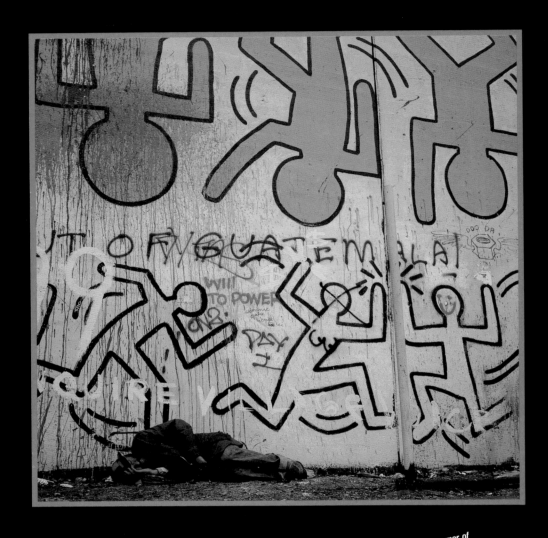

The wall on the northwest corner of Houston Street and the Bowery has borne a changing exhibit of graffiti murals ever since the day in 1979 when Tom Otterness, who lived across the street, went at it with a spray can. Many of the murals, like this one by Keith Haring, have been commissioned; many more, like those that covered Haring's, have simply appeared.

STREETS

"The streets belong to the people," went the late '60s rallying cry. A generation later, posters, graffiti, and street art in various guises are giving substance to that credo. Such private gestures in public places are nothing new, of course. Graffiti has been around as long as there have been rocks, trees, and walls on which to carve, mark, or spray testaments for the world to see. "John Loves Mary—Forever." "Kilroy Was Here." Posters—as announcements, as art, and often as announcements for art—have a history that goes back at least to the origins of printing. The gestures and events we now call street art, in their turn, date back far beyond open-air Happenings of the 1960s to the religious pageants and military parades that dot human history. What distinguishes the current incarnations of these age-old forms is their highly self-conscious use of public places to pose often profound questions about individual identity. Although much of the work is nothing more than vandalism, the best of it illumines the personal, civic, and even legal identity of those of us who inhabit an urban world of physical and psychological violence.

Crash, Daze, SAMO, Futura 2000, Zephyr, Fab Five Freddy, Lee, Lady Pink—these are signatures the art world has come to recognize on slick, brightly colored canvases in galleries around the world. But these names are at once more and less than signatures;

43

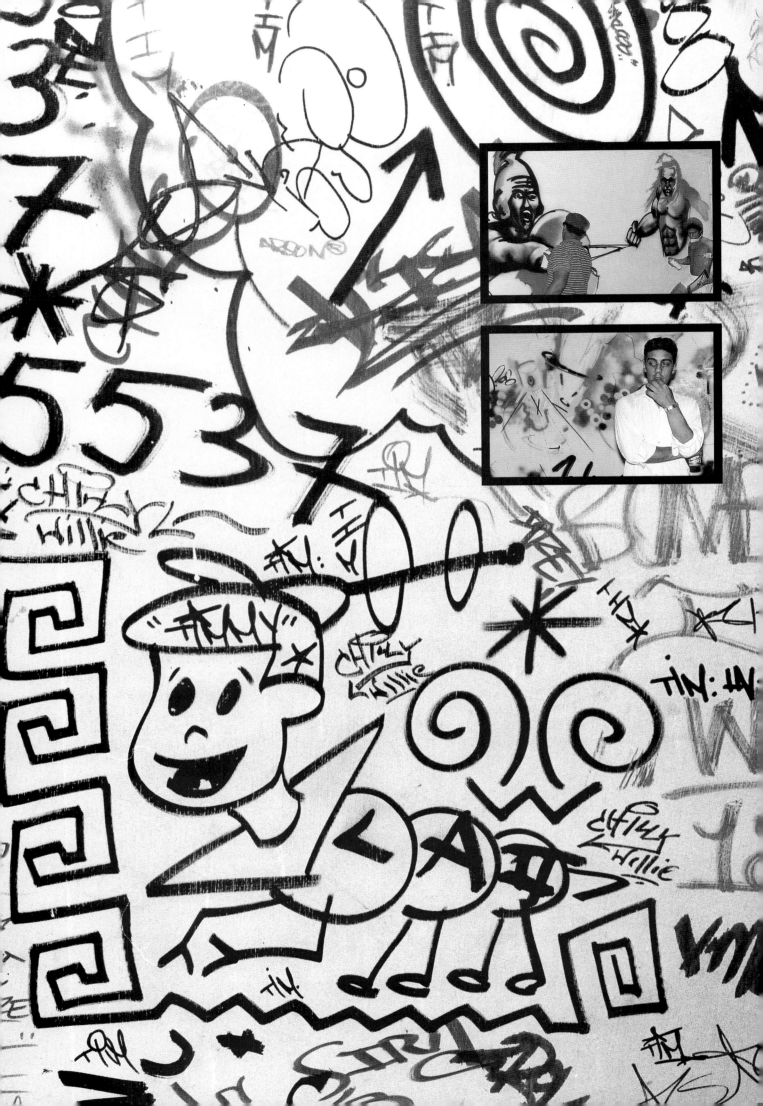

they are the "tags" of the most successful graffiti writers who have graduated from subway cars to collectors' walls. The story of how these street kids became artists, some with international reputations, began almost twenty years ago.

As members of the "love generation" of the later 1960s became more politicized and anti-establishmentarian, they began to prefer writing on public walls as a way of declaring their stance in word and in deed. At the same time, the teen and subteen children of New York's lower middle class also began to write on the walls, but not to the same ends. These children weren't proclaiming social and political views, they were simply asserting their own identities. Out of adolescent need, these kids from various neighborhoods and ethnic derivations were leaving their mark on otherwise anonymous surfaces. Their "marks" were public personae that masked their legal identities but amplified their presence among their peers: a first name or nickname, frequently coupled with a street number.

At first confined to neighborhood walls, these young "writers" soon found that when they "hit" the interiors and exteriors of subway trains and stations, their tags and subsequent fame would travel much farther than they themselves would on the way to and from school. Julio 204—a guy, apparently Hispanic, named Julio, who lived on 204th Street (East? West? Manhattan? Bronx? Queens?)—was the first to spread himself throughout the subway system; by the spring of 1968 you could find his tag in Times Square and near Shea Stadium, in the Bronx and down by Wall Street. But it was Taki 183—a Greek kid named Demetrios from 183rd Street—who opened the floodgates early in 1970. Within a year the New York subway system had a "graffiti problem." And New York artists and writers, journalists and radical theorists, had themselves a new form of artistic expression, issued indigenously from the people, by the people, and for the people.

While Manhattan critics were debating whether graffiti was art, it was inarguably being practiced as one. By the mid-'70s graffiti writers had become considerably bolder; not only were they festooning subway car interiors with their little tags, they were now sneaking into railyards at night and emblazoning huge, multicolored versions of their tags across whole sides of cars. The best of these vast compositions, enhanced cartoon images borrowed

Graffiti artists in action. Reviled by officials and lauded by scenemakers for "hitting" the subway and other public places with their "tags," graffitists have also caused controversy by leaving the streets for the galleries. When "real" artists began to do graffiti works, like these images stenciled to walls by David Wojnarowicz, they often sought to convey oblique and even direct political messages.

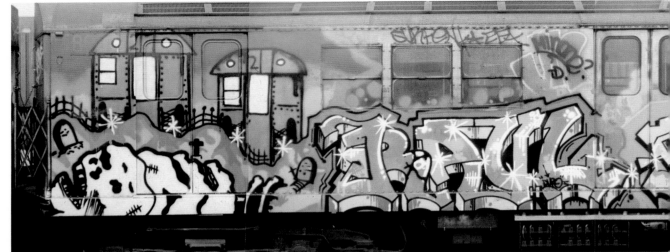

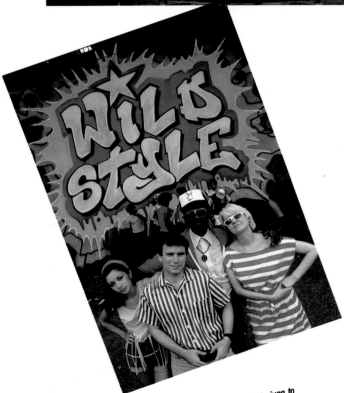

"Wild Style" was the label given to the hyper-vibrant, almost illegible manner of writing favored by graffiti artists at the time of their greatest visibility. Adding to this visibility was Charlie Ahearn's part-fiction, part-documentary 1982 film that took its name from the writing style. Here, the director and his stars.

from underground cartoonists like Vaughn Bode, were dubbed "masterpieces." By this time graffiti writers were recognizing one another as "masters" and "apprentices," with the latter graduating to the status of the former upon realization—and recognition by others—of a "masterpiece." An organization called United Graffiti Artists attempted to legitimize the practice by bringing it off the streets and into an uptown loft. In 1975, the UGA showed its wares—relatively large canvases based on the "masterpiece" styles of its members—at Artists Space, probably the first gallery display of graffiti. The show attracted a reasonable amount of attention from the art world, but not enough to inaugurate a whole new art form. Interest in graffiti—by critics and practitioners alike—waned for a few years thereafter.

Even as graffiti went into temporary eclipse, more or less legitimate artists began producing art for and about the streets. A gaunt, elusive painter named Richard Hambleton tattooed the urban landscape with a pair of outdoor multiple works, *Image Mass Murder* and *Shadows*. If Hambleton's work can be classified as site-specific art, the sites they show us reveal the atmosphere that was enveloping American cities in the '70s. It was a time when people feared to leave their homes, anticipating mugging, rape, and murder at every street corner.

For *Image Mass Murder*, Hambleton drove, bused, and hitchhiked to cities across the country, tracing the fallen human form on urban sidewalks with white paint, the way the police do to mark the site of a murder. Ham-

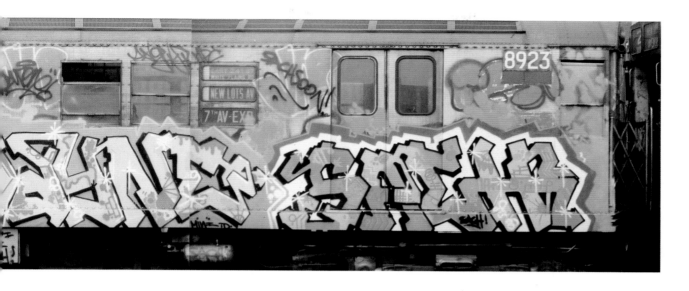

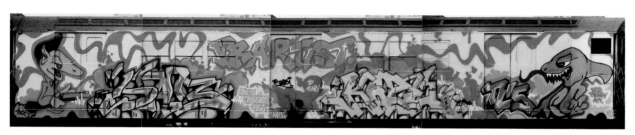

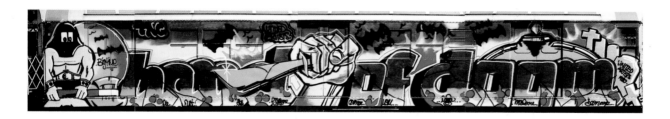

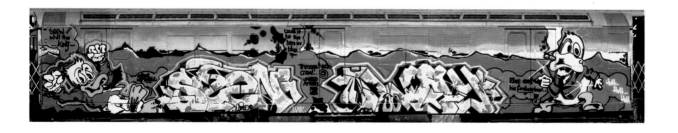

Graffiti first became an art issue when young ghetto "writers" began adding color, eccentric form, and pictorial embellishment to their subway writing in the mid-1970s. Size as well as visual dynamics became more and more exorbitant. By 1980 the New York subway was a vast rolling gallery of elaborate spray-paint murals.

SEEN P JAY, 1980
SAB KAZE, 1982
LEE QUINONES (aka ZORO), 1979
DUST SIN, 1982

47

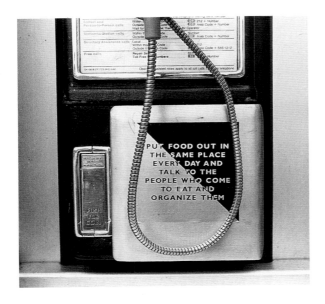

PUT FOOD OUT IN THE SAME PLACE EVERY DAY AND TALK TO THE PEOPLE WHO COME TO EAT AND ORGANIZE THEM

ABUSE OF POWER SHOULD COME AS NO SURPRISE
ALIENATION CAN PRODUCE ECCENTRICS OR REVOLUTIONARIES
AN ELITE IS INEVITABLE
ANGER OR HATE CAN BE A USEFUL MOTIVATING FORCE
ANY SURPLUS IS IMMORAL
DISGUST IS THE APPROPRIATE RESPONSE TO MOST SITUATIONS
EVERYONE'S WORK IS EQUALLY IMPORTANT
EXCEPTIONAL PEOPLE DESERVE SPECIAL CONCESSIONS
FAITHFULNESS IS A SOCIAL NOT A BIOLOGICAL LAW
FREEDOM IS A LUXURY NOT A NECESSITY
GOVERNMENT IS A BURDEN ON THE PEOPLE
HUMANISM IS OBSOLETE
IDEALS ARE EVENTUALLY REPLACED BY CONVENTIONAL GOALS
INHERITANCE MUST BE ABOLISHED
KILLING IS UNAVOIDABLE BUT IS NOTHING TO BE PROUD OF
LABOR IS A LIFE DESTROYING ACTIVITY
MONEY CREATES TASTE
MORALS ARE FOR LITTLE PEOPLE
MOST PEOPLE ARE NOT FIT TO RULE THEMSELVES
MOSTLY YOU SHOULD MIND YOUR OWN BUSINESS
MUCH WAS DECIDED BEFORE YOU WERE BORN
MURDER HAS ITS SEXUAL SIDE
PAIN CAN BE A VERY POSITIVE THING
PEOPLE ARE NUTS IF THEY THINK THEY CONTROL THEIR LIVES
PEOPLE WHO DON'T WORK WITH THEIR HANDS ARE PARASITES
PEOPLE WHO GO CRAZY ARE TOO SENSITIVE
PEOPLE WON'T BEHAVE IF THEY HAVE NOTHING TO LOSE
PLAYING IT SAFE CAN CAUSE A LOT OF DAMAGE
PRIVATE OWNERSHIP IS AN INVITATION TO DISASTER
ROMANTIC LOVE WAS INVENTED TO MANIPULATE WOMEN
SELFISHNESS IS THE MOST BASIC MOTIVATION
SEPARATISM IS THE WAY TO A NEW BEGINNING
SEX DIFFERENCES ARE HERE TO STAY
STARVATION IS NATURE'S WAY
STERILIZATION IS OFTEN JUSTIFIED
STUPID PEOPLE SHOULDN'T BREED
TECHNOLOGY WILL MAKE OR BREAK US
THE FAMILY IS LIVING ON BORROWED TIME
THE WORLD BELONGS TO NO ONE
TIMIDITY IS LAUGHABLE
TORTURE IS HORRIBLE AND EXCITING
TRANS[...] OR A LIFE IS FAIR ENOUGH
U[...] 'T BE THE MOST VALUABLE
[...] RAVE
[...]U HAVE FREEDOM OF CHOICE

"I guess my art evolved out of my mid-'70s job as a typesetter," explains multimedia sloganeer Jenny Holzer. Words are her basic medium, but she presents her foreboding and subversive phrases in as many formats as she can manage. Most of these formats are public: pamphlets, wall posters, stickers, and even moving electronic signs.

JENNY HOLZER
"Put food out in the same place . . . ," 1984
Offset on paper

"Abuse of power," 1979
Offset on paper

48

bleton did this entirely anonymously, without prior or subsequent announcement, and such anonymity only provoked mass-media coverage. After that success, Hambleton began painting "shadows" in a painterly, even splattered manner on the walls of buildings in major cities. If the sidewalk markings of *Image Mass Murder* elicited surprise and morbid curiosity, the eerie *Shadows* exploited people's deeply felt anxieties about the city streets. Almost everyone who lived in New York at that time has a story to tell about the night they were scared witless when they turned a corner to see a Hambleton shadow in a parking lot or on a side street.

Hambleton emerged from the shadows with full-length photo-images of himself, affixed where the earlier shadows had or could have been painted, and with a touring show documenting *Image Mass Murder.* Now settled in New York, Hambleton has since moved his work indoors. "I'm dealing with feelings and human emotions," he explained in reference to his outdoor work. There is no doubt that Hambleton succeeded by that criterion; the complaint of many was that the feelings it evoked were too strong.

Hambleton's street work literally startled its viewers into an awareness of just how affected they were by the reality—and the expectation—of physical violence on city streets. At about the same time, Jenny Holzer began a body of work that jars its audience into consciousness of a different but equally destructive affront that goes unchecked in the public arena—the abuse of language by commercial and political interests. An early Colab member, Holzer began her work in conjunction with Colab's various guerrilla gallery shows. Her usually small, unadorned posters—which Holzer classifies either as "truisms" or "inflammatory essays"—bear incongruous or obliquely related clichés, normally of her own coinage but based on the fatuous bromides and banal advertising slogans that infect the awareness of contemporary urban dwellers. Through wry variations, subtly discordant conjunctions, and insistent, plodding typography, Holzer inverts the meanings of such verbal Muzak. Although her posters are visually less engaging than the billboards they paraphrase, their very clumsiness is what attracts attention; and their subversive vapidity is what distances them from their commercial sources. Begun on the streets, by 1982 her work was being

JENNY HOLZER
Selections from the Survival
series, 1983
Unex electronic signs, each
30½ x 113½ x 12"
"You spit on them. . . ," 1986
Black granite, 17¼ x 36 x 15¾"

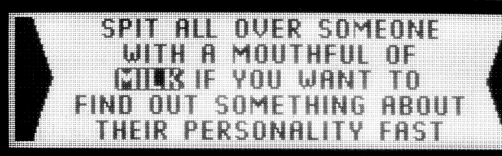

SPIT ALL OVER SOMEONE
WITH A MOUTHFUL OF
MILK IF YOU WANT TO
FIND OUT SOMETHING ABOUT
THEIR PERSONALITY FAST

WHEN YOU EXPECT FAIR PLAY
YOU CREATE AN INFECTIOUS
BUBBLE OF MADNESS AROUND
→YOU←

YOU SPIT ON THEM BECAUSE THE
TASTE LEFT ON YOUR TEETH EXCITES.
YOU SHOWED HOPE ALL OVER YOUR
FACE FOR YEARS AND THEN KILLED
THEM IN THE INTEREST OF TIME.

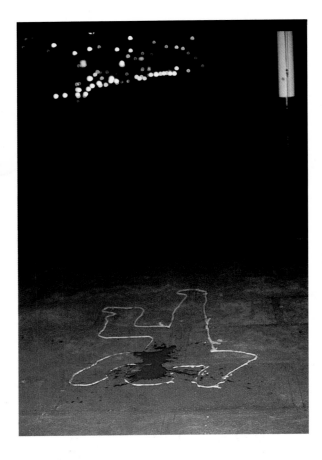

shown in museums and galleries. By that time she had also begun to create bronze plaques bearing her cockeyed adages. She affixed these plaques to the sides of selected buildings in a burlesque of commemorative markers. Reading one of Holzer's reactionary or revolutionary truisms on a poster or plaque, casual passersby cannot help asking what, if anything, the anonymous posterizer actually believes about the subject. As Holzer's random viewers continue down the street, they must wonder, if only momentarily, who or what could have been responsible for these cryptic messages, and what they as viewers were expected to gain from them.

Hambleton and Holzer began their outdoor work at a time of waning interest in graffiti, but by the time they had made names for themselves, graffiti tags had returned—with a vengeance. In the years since graffiti made its first mark on the art world, the multiple calligraphic styles practiced by graffiti writers had gradually merged into one: the florid yet streamlined, and almost totally illegible "wild style." Meanwhile, "legitimate" artists, both in Colab and out, began to take an active interest in graffiti and in the kids who were doing it. The South Bronx storefront gallery Fashion/Moda brought downtown artists uptown to meet the graffiti writers. Downtown, Keith Haring curated an exhibition of graffiti at the Mudd Club. "I got fired right after I curated the graffiti art show," Haring recalls. "The club and much of the surrounding area got covered with graffiti and Steve Mass got mad. I don't know what he thought would happen; I mean there were like hundreds of the best writers in the city at the Mudd Club that night."

Charlie Ahearn, twin brother of the sculptor John, gave graffiti its most dramatic showcase: a feature-length film entitled *Wild Style.* Two front-line graffiti writers, Lee Quinones and Lady Pink, headed a cast that included a hefty sampling of the best break dancers and hip-hop DJ artists; Glenn O'Brien, *Interview* magazine writer; and a dizzy blonde with a lively past who called herself Patti Astor. By 1981, graffiti was being featured in legitimate public venues like P.S. 1, the vast Long Island City schoolhouse that attracted young artists as well as established art world officials. And that same year Patti Astor and Bill Stelling founded the Fun Gallery, an ad hoc storefront far from other commercial galleries showing the work of Astor's graffiti

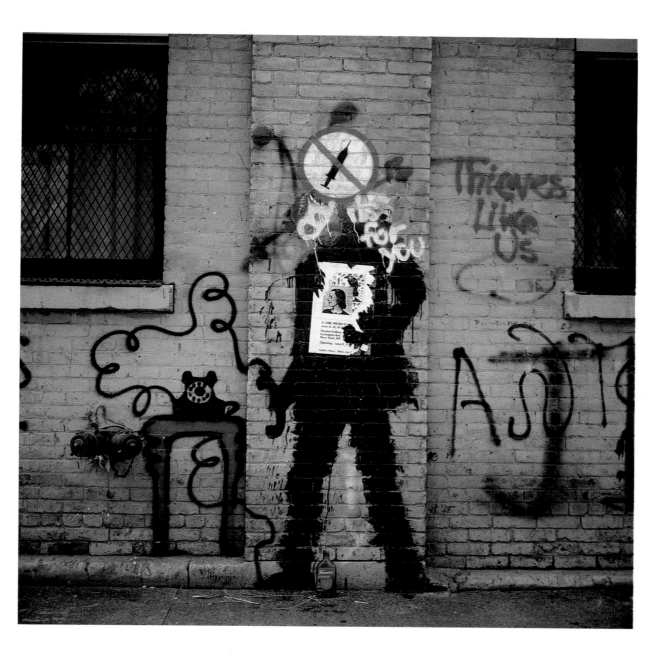

After creating his even more fearful multi-city outdoor-art piece Shadows, Richard Hambleton came forward as the perpetrator of these anxiety-inducing apparitions. "I wanted to combine site-specific earthwork and classic painting techniques," Hambleton explains. He also wanted to scare the bejeezus out of an already wary urban population. The telephone and other graffiti on and around the Shadows were added later by others.

RICHARD HAMBLETON
From Shadows, 1980–81

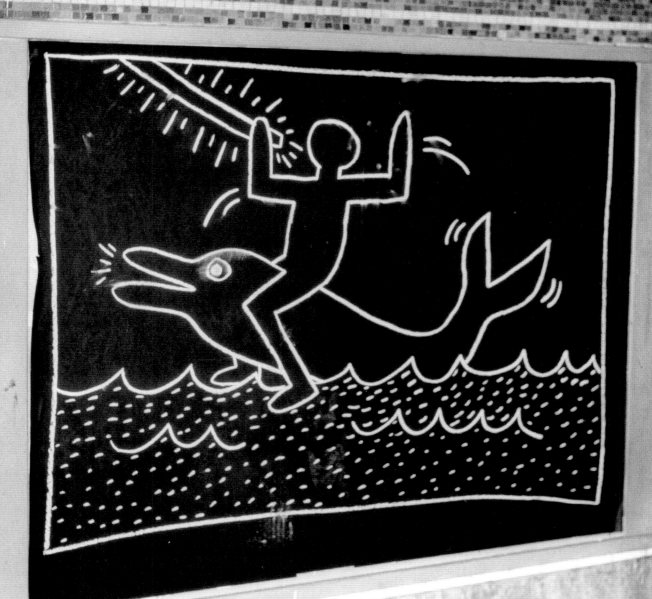

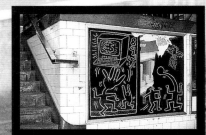 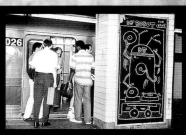

artist costars from *Wild Style*. "We opened the gallery," Stelling says with a smile, "because I got a tax return which was enough to pay the rent for a small store and buy several cases of beer. We had no great pretense or ambitions about fine art or culture. We just showed what we liked and tried to have as many parties as possible. . . . The name was a pretty good summary of our philosophy." Thus an odd but increasingly tight alliance between rebellious elements of the art world and restlessly creative but less privileged youth was forged.

It wasn't only the artists who reached out to the graffitists; at least a few of the subway writers reached out to the art world. At about the same time that Jenny Holzer began postering Manhattan with her linguistic subversions, a writer named SAMO emerged to write graffiti on the walls of SoHo and other fashionably bohemian neighborhoods. SAMO's graffiti wasn't a simple matter of "tagging," however. It was a blunt, often rousing, and just as often poetic social critique, mocking and cynical, if less ironic than Holzer's postered clichés. SAMO would make promises ("SAMO as an escape clause"), withering observations ("riding around in Daddy's convertible with trust fund money"), and oblique declarations ("plush safe. . .he think").

SAMO's last writings were announcements that SAMO himself, complete with copyright symbol, was dead. And the word came out that SAMO was actually two people, young artist-musicians from the *barrio* named Jean-Michel Basquiat and Al Diaz, whose falling-out precipitated this sad but inevitable obituary notice. By this time Basquiat had entrée into art circles through artists and art students hip to his modus operandi. In 1980 Basquiat-cum-SAMO participated in the *Times Square Show*, contributing, in Jeffrey Deitch's words, "a knock-out combination of de Kooning and subway spray paint scribbles." At the time, Basquiat was wallowing in poverty, painting and drawing his scrawny personages and ruminative notations on any surface available to him—from his own refrigerator to the refrigerators, doors, and walls of anyone and anywhere he visited. Soon, however, he had a major gallery and an international art world following.

While Basquiat was coming up from the subways, Keith Haring was descending into them to make his art and reputation. In the late '70s and early '80s Haring had organized several graffiti exhibits at various clubs. He

While Haring seeded the subway with his rollicking icons, SAMO was spreading a caustic and crazy philosophy above ground. The two or more young artist-musicians working under the SAMO moniker wrote phrases of biting social observation on walls, park benches, lampposts, and even articles of clothing worn by friends.

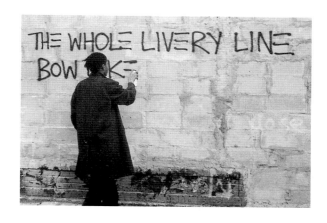

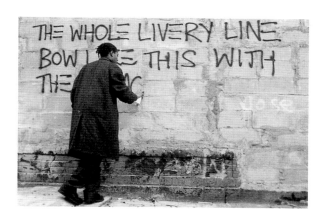

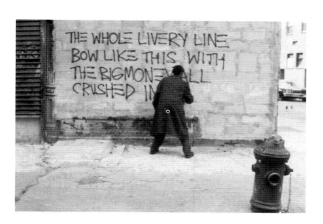

States Keith Haring modestly, "Everything I ever dreamed I could accomplish in art was accomplished the first day I drew in the subways and the people accepted it." Since then, Haring's cartoonography has emerged from its subterranean birthplace to enjoy public acclaim and commercial success.

53

While graffiti-art canvases have been shown in galleries, alternative spaces, and even museums, many observers feel the form belongs outside, that graffiti's raw, cocky energy is compromised when seen in the tidy, genteel context of the art world. Others find that the style's brashness and insouciant glitz is a breath of fresh air in the rarefied domain of fine art.

JOHN "CRASH" MATOS
Untitled, 1986
Spray enamel on canvas and wood, 48 x 120"

AARON "TEE BEE" GARRETT
Stepping Out, 1984
Acrylic airbrush on canvas, 84 x 72"

CHRIS "DAZE" ELLIS
Chill Image, 1983
Acrylic on canvas, 93 x 53"

ANTON VAN DALEN
The Shooting Gallery, 1982
Offset poster, 18 x 24"

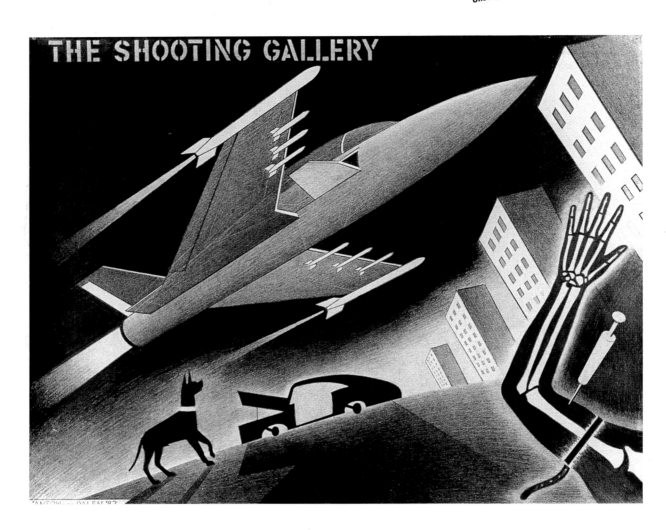

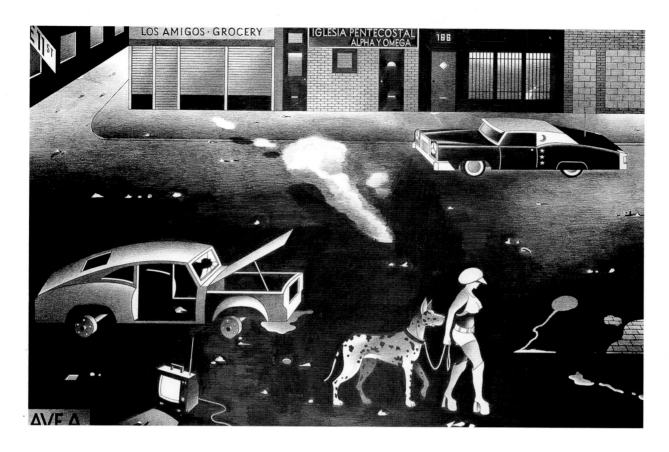

was also making change doing some gofer work for Tony Shafrazi, a former artist who had opened a gallery in his apartment on lower Lexington Avenue. And, in his spare time, Haring was slapping up posters of his own invention (notably a series of false newspaper headlines like "Pope Marries"), hanging out with graffiti writers, and even doing some "hitting" himself. But unlike the other subway artists, Haring did not work principally in spray paint on metal; he preferred to work with a much less permanent medium, chalk, and to deface the most faceless surfaces of the underground world, the empty advertisement spaces dotting the subway walls and covered over with black paper, awaiting the next ad.

On these public blackboards, Haring drew his stark, extremely stylized figures in thick white outline. The white-chalk-on-black-paper format clearly conjured up the schoolroom, investing Haring's drawings with both familiarity and authority. Frequently his images had social and political import, satirizing or protesting pollution or nuclear weaponry or the anesthetizing influence of television. Haring's style, his choice of subjects, and his format clearly distinguished him from other subway graffitists and even from other artist

Dutch-born Anton van Dalen has lived and worked on Avenue A for a good twenty years. His neighbors now include some of the area's most fashionable galleries, boutiques, and restaurants. But as his pictures attest, van Dalen remembers all too well the ungentrified East Village of yore. Van Dalen made one of his images, "The Shooting Gallery," into a poster—which he then used to seal up the holes in abandoned buildings through which dealers passed drugs to junkies.

ANTON VAN DALEN
Night Street, 1976
Graphite on paper, 40 x 60"

MARTIN WONG
Fifth Avenue near 45th Street,
Brooklyn, 1985
Oil on linen, 18 x 103"

Portrait of Mickey Pinero at Ridge
Street and Stanton, 1985
Acrylic on canvas, 72 x 72"

Like van Dalen, Martin Wong, erst-
while criminal court sketch artist
and while-U-wait portraitist, has
devoted his oeuvre to portraying
the mean streets of the Lower East
Side. In this image Wong repli-
cates the graffiti-covered Attorney
Street handball court and, in inter-
national hand-sign language, su-
perimposes a poem by his friend
playwright Miguel Pinero. This is
the first painting the now-success-
ful Wong ever sold—and the buyer
was the Metropolitan Museum of Art.

Attorney Street Handball Court
with Autobiographical Poem
by Pinero, 1982–84
Oil on canvas, 35½ x 48"

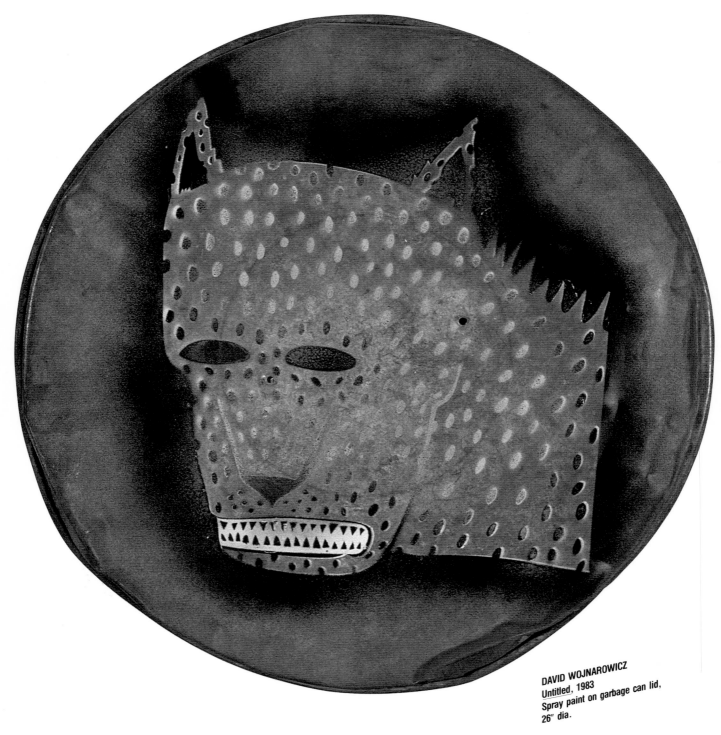

DAVID WOJNAROWICZ
Untitled, 1983
Spray paint on garbage can lid,
26" dia.

friends like Kenny Scharf who were also be-
ginning to leave their marks in subways and
on city walls. Charming in its wit and in the
naively eloquent political commitment of its
subject matter and radical simplicity of its
form, Haring's art readily appealed to the av-
erage subway rider. In short time Haring's
crawling baby and nuclear television set
had become familiar icons to millions of
commuters.

Haring was busted frequently enough for
his escapades, but in the face of these setbacks
he would simply restate his desire to do art

everyone could see and understand. Given this populist generosity, Haring became something of an artistic Till Eulenspiegel, entertaining the public at large and tweaking the nose of officialdom with full knowledge of the risks involved. And his generosity extended beyond the "offerings" of the subway drawings: before he began marketing his work through his Pop Shop, Haring was producing thousands of buttons and posters bearing his motifs, not for sale, but as giveaways. Although he shows in the galleries and markets his own work globally, Haring continues to see the subways as a viable space for art. "I keep wishing," he says, "that someone would take up where I left off. There is an obvious thing to do next. If I weren't Keith Haring and I had just come to New York, I would know exactly what to do in the subways."

Haring's international success turned the graffiti ripple into a tidal wave of art in public spaces. A continuous chain of posters, stencils, murals, prints, and even paintings and sculptures links TriBeCa, SoHo, and the East Village, running a distance of nearly three miles. Many artists have used the streets as a runway into the gallery world. One East Village veteran has taken to plastering up small but obtrusive stickers with nothing on them but his name. Hambleton's shadows, Holzer's posters, Haring's chalk drawings, and the wild-style tags of a generation of graffiti artists affected the psychological, political, and aesthetic sensibilities of their street audiences because of what they did to where they were. Addressing a large but casual urban audience from subway platforms, corporate facades, and dark street corners, this body of street work at its best spoke to people not as gallery-goers but simply as inhabitants of a common and endangered urban environment. Whatever power and intrigue street art loses when transferred to the indoor environment of galleries and museums, such work has nonetheless had a profound influence on the art world. As Glenn O'Brien jokingly but accurately states, "The art world is changed forever now that they've finally let the heathens in. Subject matter and colors which were previously dismissed as vulgar have been added to the artists' vision." Jeffrey Deitch elaborates on the same point, predicting that "the future of art is the Third World sweeping through and changing things." Street culture is the first outpost of that third world, metaphorically and literally.

David Wojnarowicz at work in an abandoned building.

By now much of downtown Manhattan has been blanketed with wall art of every description. Much of it is just so much noodling, doodling, and blatant self-promotion. The work of a few talents, however, stands out, obviously the result of a genuine commitment to an art created al fresco and offered free to the public. Scot Borofsky is notable among these. He has turned the city block bounded by 5th and 6th streets and avenues B and C into a vibrant "Pattern Walk."

SCOT BOROFSKY
Dog-o-D, 1983
Spray paint on metal

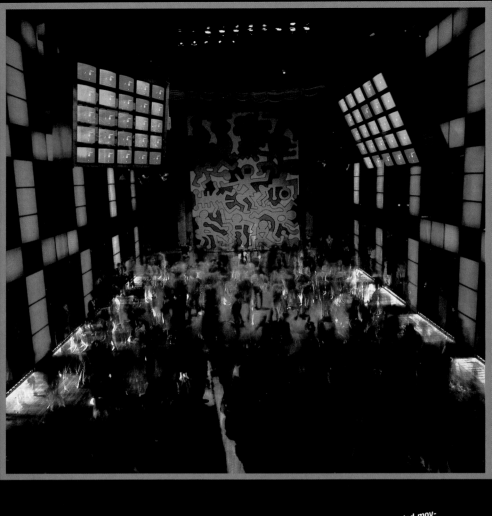

The Palladium is a converted movie theater featuring changing art shows and a continuous succession of art-world events and receptions. It also contains several semipermanent commissioned works, like this dance floor mural by Keith Haring.

NIGHTS

By 1978 rock had been successfully repackaged and resold as a 120-beats-per-minute mechanism called disco that had the sound of funk but the soul of Muzak. Meanwhile, the alternative spaces to which artists had turned during the cultural hangover of the Vietnam and Watergate years were themselves going the way of fixed programming and creeping institutionalization. One could blame it on the economy; one could blame it on the government; one could blame it on the art system. What did it matter when it just wasn't happening?

In October 1978, a self-described "crank anthropology scholar" named Steve Mass invested fifteen thousand dollars in a downtown bar he called the Mudd Club. At the time, few New York clubs provided alternatives to the lowest-common-denominator appeal of disco. Max's Kansas City was a longtime staple of the downtown crowd where the glitterati could exercise their more extreme, less commercially viable impulses; CBGB/OMFUG was a dive with a stage that became the launching pad for New York Punk. Each had a reputation as an artists' hangout, but both were really just straight-ahead rock clubs where a few artists went to hear music and have a beer. Mudd had a different program.

The idea behind Mudd was to have parties that would thrust rock music punks, groupies, street hookers, the art crowd, Wall Street exec-

63

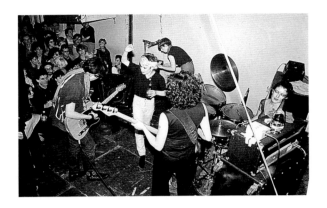

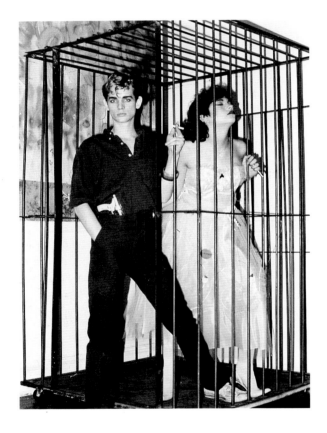

"In retrospect," says Steve Mass, owner of the legendary Mudd Club, "it seems appropriate to call the entertainment I provided my clientele with 'art.' At the time it drove people out the door as often as it drew them in." One of the better bands featured at the Mudd was the avant-girl group the Bloods. Another of the livelier Mudd features was the cage for species Homosapiens, built by Ronnie Cutrone originally as a sculpture. The cage served as a formidable stage prop for, among others, Grace Jones, Walter Steding, and the B-52s.

utives, and New Jersey hoods into one room just to see what would happen. On Halloween of 1978, Mass booked a bizarre band named the B-52s, who at the height of the Neo-Psycho Punk movement stepped onto the stage and announced, "Hi. We're a dance band from Athens, Georgia." Fred Schneider, lead singer of the B-52s, remembers: "It was a wild night. I was dressed as a hangover, and the band all had on crazy costumes. Somebody in a huge lobster outfit jumped up on stage and started dancing. I guess the lobster couldn't see anything because it fell right through a hole in the floor, knocking over half of our equipment." The B-52s took off, and so did the Mudd Club.

Mass ended up running a laboratory for the bizarre and the creative. He welcomed input of whatever kind from rockers, fashion freaks, artists, and anyone else with a creative bent. His own instinct, according to the testimony of all who worked with him, found its outlet in the mix of people he deliberately and successfully attracted to the club—and in the rough-hewn, permanently temporary ambience in which painters and potheads, bikers and businessmen, could freely mingle. On a good night, the chemistry was more than a match for Mass's anthropological studies. The scene looked like a wacko comic book convention, with conventioneers ranging from bearded intellectuals and svelte suit-and-tie characters to mohawked and skinheaded space cadets escaped from a science fiction parody. "On a level of amorous interest," Mass recalls, "we had some truly bizarre love triangles involving older artists and teenyboppers, curators and rock sleaze." And a good time was had by all.

With the alternative art spaces becoming less alternative and more structured, Mudd provided a place where, as Andy Warhol observed, "they call mistakes experiments." One of the first artists to help mold the club's artistic policy was Ronnie Cutrone, a former Warhol assistant. "At Max's and the other early art bars," explains Cutrone, "it was all art babble. . . . The Mudd Club hit on the idea of art in action rather than just art talk."

Mass exploited every art form. Television sets hung over the bar, and the fare was as likely to be *The Gong Show* as it was Nam June Paik and other video artists. Musicians of all kinds shared the stage with performance artists, avant-garde cabaret performers, and whoever else had concocted a presentation.

Corny, elaborately skewed variety shows became frequent, as did "theme parties" thrown by the likes of underground starlet Tina Lhotsky (who put together a Pajama Party, a Cha-Cha Party, and a Joan Crawford Mother's Day Celebration) and boutiquettes Tish and Snookie Bellamo (who, fittingly, mounted a '60s revival bash).

Two months after its opening, Mudd had been transformed from a one-floor, out-of-the-way bar to a multileveled, multimedia talk-of-the-town art-and-performance club. Eventually the fourth floor of the TriBeCa loft building became a makeshift gallery, where Mudd's art regulars exhibited their wares. Several young art dealers started scouting the scene—including Tony Shafrazi, Anina Nosei, Mary Boone, and Gracie Mansion. Art in clubs was a red-hot reality, and, as Mass notes, "Realistically, the Mudd Club was the best publicity vehicle SoHo ever had." The art world, closed and incestuous during the nearly two decades since the pop/rock explosion, had found a way to connect to the culture at large: weird characters and talk of money in a late-night dance bar.

Across town, in the then seedy East Village, Ann Magnuson, a clever young actress and organizer, was running Club 57, a tiny but zany cabaret in the basement of a Polish church on St. Mark's Place. Club 57's real origins were in a daffy stage revue, the *New Wave Vaudeville Show*, presented early in 1979 at a Polish war veterans' club called Irving Plaza. The show was an underground smash; among other things, it launched the career of the phenomenal "space age" singer Klaus Nomi, who sang German opera to thunderous applause and tore down the house. The proprietor of Irving Plaza also managed the Polish church on St. Mark's and offered its use to Tom Scully and Susan Hannaford, the organizers of the *New Wave Vaudeville Show*. There, Scully and Hannaford launched the Monster Movie Club, featuring cheesy horror flicks on Monday nights. The screenings became East Village social events of a sort, inspiring the folks in charge to turn the place into a full-fledged club—one that still showed B-movies—and to set up actress Ann Magnuson, director of *New Wave Vaudeville*, as its manager.

While Mudd was a bastion for post-Punk aloofness and ultracool severity, Club 57 was a sort of frat house gone wild, a playpen of fanciful make-believe. Continuing the elaborately

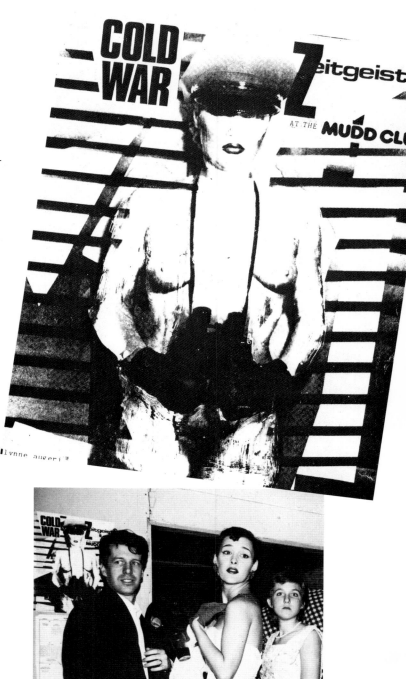

lynne augeri

Above: The Zeitgeist flyer, promising nothing but hinting at a wild time. Below: Makeup artist Wendy Whitelaw, adding to the glamorous milieu.

65

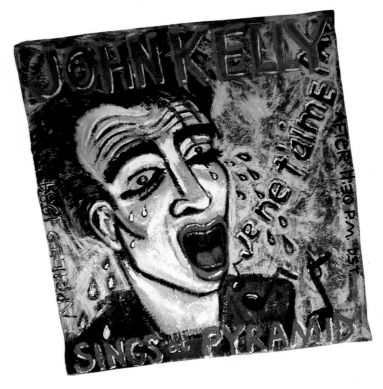

HUCK SNYDER
John Kelly at the Pyramid, 1984
Acrylic on canvas

sweet and silly conceits paraded throughout the *Vaudeville Show*, Club 57 encouraged dress-up, act-out, and sing-along. The hecklers at the B-movies went from mocking the dreadful celluloid personae to mimicking them. Private obsessions with stars, styles, sexual variations, and fads of bygone decades became the theme of the club, both on and off stage.

Among Club 57's most extravagant regulars were School of Visual Arts students Kenny Scharf, John Sex (*né* McLaughlin), and Keith Haring. They were joined by photographer Tseng Kwong Chi, graphic artist Dan Friedman, and performers Wendy Wild and Joey Arias. Scharf remained in the thrall of the made-for-television cartoons of his '60s childhood; he preached and practiced a Hanna-Barbera aesthetic, doting on chintzy sci-fi getups and painting slick comic images that evoked the world of the Flintstones and the Jetsons. Sex developed a persona that simultaneously masked and amplified his polymorphous self, elaborating a mythic yet parodic rock-star-like figure of mercurial presence. Haring, who was later hired away by Steve Mass for the Mudd Club, organized several one-night exhibits both of his clubhouse compatriots and of the street and subway graffitists he was searching out. "The best thing about art exhibits is the opening," observes Haring, "so I figured the best exhibit to have would be one where the opening was the whole show."

Acts of Live Art, a series of performances organized by Sex, brought performance art into the club context—not as an opener or a break for music, but for itself. The series continued the form and spirit of *New Wave Vaudeville* and got several people into the swing, including Ann Magnuson, who performed a full-throttle majorette routine to a Donna Summer number. Photographs of the series by Tseng Kwong Chi began that imaginative photographer's loopy underground reputation. And, of course, Sex's classmates Scharf and Haring also took part.

"I never got bogged down with the serious notion of art," says Magnuson of Club 57, "although I recognized the fact that there were several very talented artists there. I wanted to have a place where there would be no barrier between stage and audience. Out of that idea came the sometimes brilliant, sometimes ridiculous, but always crazy theme parties." In its day, Club 57 mounted a '60s-style Valen-

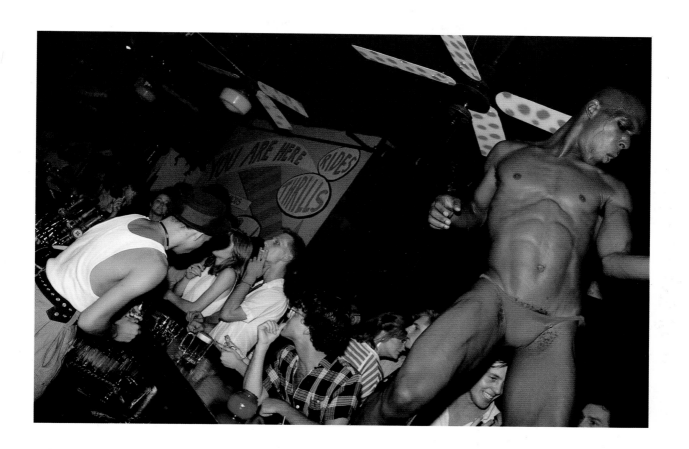

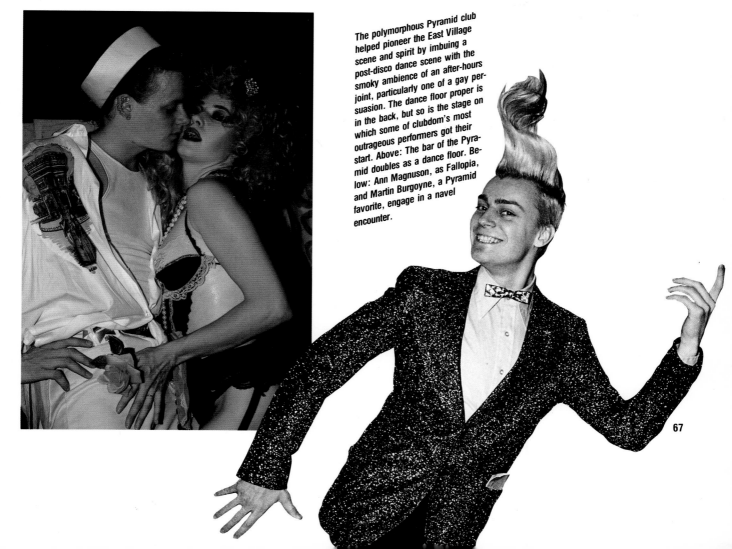

The polymorphous Pyramid club helped pioneer the East Village scene and spirit by imbuing a post-disco dance scene with the smoky ambience of an after-hours joint, particularly one of a gay persuasion. The dance floor proper is in the back, but so is the stage on which some of clubdom's most outrageous performers got their start. Above: The bar of the Pyramid doubles as a dance floor. Below: Ann Magnuson, as Fallopia, and Martin Burgoyne, a Pyramid favorite, engage in a navel encounter.

tine's Day Love-in, an early-'70s Glitter Rock revival, a miniature-golf-course-*cum*-Jamaican-shantytown (Putt Putt Reggae Night), a Punk Rock quiz show (Name That Noise), an Elvis Memorial Party, and a Model World of Glue evening. The latter resulted in a few people building models, a few sniffing glue, and the rest covering model parts with glue and igniting them to create three-foot flames. "It was," recalls Magnuson with her patented deadpan, "a scary vision for a young girl running a nightclub in the basement of an old wooden church."

If Mass ran the Mudd Club as a huge test tube, combining disparate elements to see what the reaction would be, and if the Club 57 folks ran their place as a hothouse, cultivating the exotic imaginations of several species of artist, Jim Fouratt created a club that he managed as a big petri dish. He wanted to encourage a similar amalgam of cultures but wished to wield at least some artistic direction and coordination, so that the resulting mix could yield a substantial, if not necessarily predictable, result. Fouratt was thus the first club-based impresario, exercising actual taste in his selection of art and entertainment. His own sensibilities were eclectic, encompassing everything from computer art to 1950s TV commercials, from hard-core Punk to cocktail-lounge jazz to the intense minimalist clarity of Philip Glass's solo pieces. Fouratt was thus a kind of live-act ringmaster, operating on a grand extra-musical, multimedia scale.

The first venue in which Fouratt was able to operate was Hurrah's, an uptown disco near Lincoln Center. Not surprisingly, Fouratt's gig at this out-of-the-way establishment did not last long. After a fallout with the management at Hurrah's, Fouratt teamed up with a Brazilian émigré of similar mind and resolve, Rudolf Peeper (known professionally just as "Rudolf"), and opened a club they called Danceteria. Exploiting a loophole in New York's otherwise rigid liquor and cabaret laws, they operated the club with no license of any kind for over a year. Where else could you go at five o'clock in the morning to have a drink, buy, sell, or take drugs, run into the Rolling Stones, watch X-rated Keith Haring videos, see murals by Kenny Scharf and David Wojnarowicz, and dance?

Danceteria was carefully conceived as a multimedia club. Other clubs featured film, video, and live performances, exhibits of

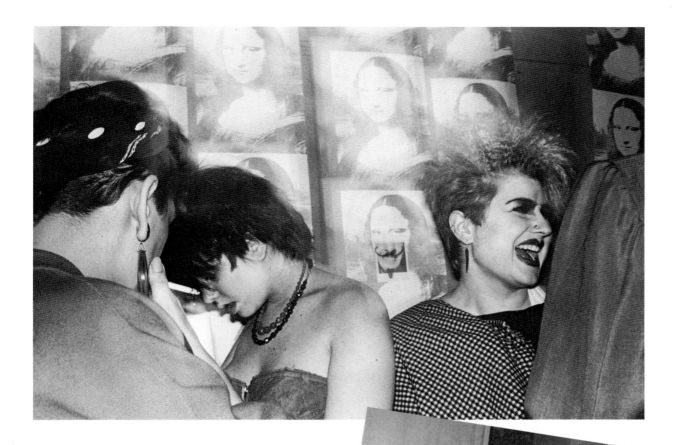

painting and photography, and much besides rock music. But, until Danceteria, the clubs had evolved their multiartistic identities haphazardly or had simply used other media as backdrops to the music, art serving as a kind of cheap substitute for light shows. Danceteria was more serious than other clubs about the art it was presenting, but no more sober.

Thanks to Fouratt's artistic discretion and Rudolf's taste for megadose, every art form was treated to focused attention. It could be difficult to look at shows of painting, photography, or artists' furniture while people danced right next to them, but usually, if not always, each art could be appreciated quite alone. At the same time, the whole multimedia smorgasbord could be sampled by any adventuresome visitor.

Danceteria struck every fancy from art and fashion to business and politics, and its praises were sung throughout the media. Unfortunately, all the coverage prefixed the club's illegal status with the word "blatantly." "What accelerated our closedown," explains Rudolf, "was that the Democratic Convention wanted to have their party at Danceteria because they saw it in *Vogue* or something." For reasons not hard to imagine, Rudolf refused

From the first, the clubs acted as gaudy backdrops for outrageous fashion "statements," many of which have influenced later haute couture creations. These, in turn, often debut on club runways.

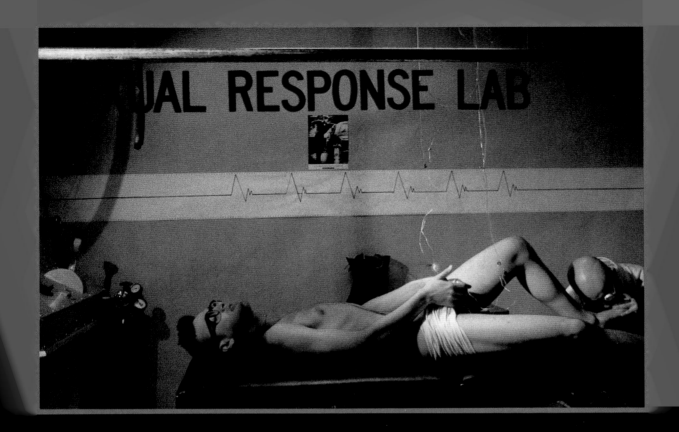

UAL RESPONSE LAB

Just when you thought it was safe to leave the art galleries and go back into the clubs, Area came along with its boogy-in-the-museum angle. By spiking Club 57's theme-party concept with $60,000 budgets for building huge and intricate displays and dioramas, Area's owners and advisers have transformed the club time and again according to witty and often sophisticated themes. Left: Various art installations at Area. Above: A response to "Human Sexual Response."

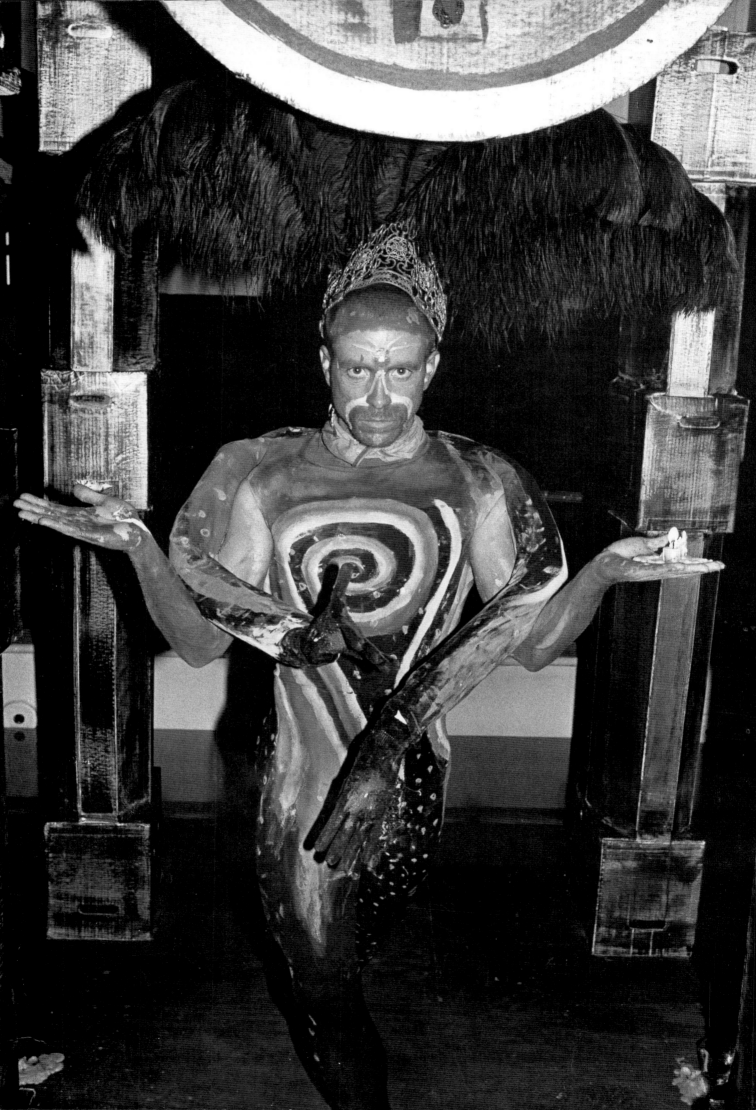

Jimmy Carter and his CIA and FBI companions, leading to the questioning that ultimately closed the original Danceteria.

A host of other clubs opened in the early '80s. East Village outposts like the Pyramid Club and 8BC followed the Club 57 example, energizing decrepit spaces with a superimposed variety of media and programs of music, performance, film, and one-night art exhibitions. By contrast, a club called Area has taken the more curatorial approach of Danceteria several steps further. Opened in the fall of 1982 by four young pranksters with a penchant for party giving, Chris Goode, Eric Goode, Shawn Hausman, and Darius Azari, Area has expanded the concept of the theme party: the club is totally rebuilt every six weeks. Area pays artists for all materials and provides them with carpenters and other craftspeople to create installations and large-scale sculptures on a given theme. The result is a museum period room gone wild, a gallery where you can drink, dance, and let go.

"When I first moved to New York," Area's Eric Goode recalls, "I went out every night. I actually came here to study art, but I became obsessed with the nightlife—Studio 54, Club 57, and the Mudd Club especially. It all seemed so much more inventive, more daring, more interesting than the galleries at that time." Azari, Hausman, and Eric's brother Chris shared this view, and so, armed with hammers, saws, sanders, and screwguns, they built their idea of a twelve-thousand-square-foot art installation party palace.

At the time of its opening, Area seemed like a huge, slick, commercial palace, and it was an immediate financial success. Nonetheless, on a given night the informed Manhattan-dweller could be assured of a truly wild time courtesy of the wacko aesthetic of Area's brain trust. Events have included Free Sex Night, which assured live sexual contact; Religion Night, where no faith was spared crucifixion; and Experimental Studies, whose invitation—government issued, mind you— was a microdot of LSD.

The current "state of the art" club, Palladium, made quite a splash when it debuted with a voluptuous interior designed by vanguard Japanese architect Arata Isozaki, artsified with interior embellishments by Basquiat, Haring, and Scharf. The effect is rather like an art shopping mall, its tenants selling you at every turn. The Palladium, like the other megadisco clubs of the late '80s, was

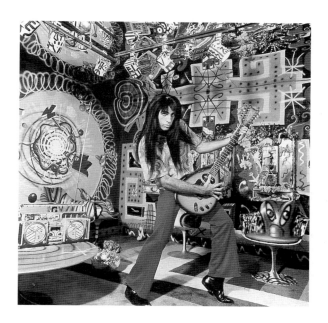

The world's great faiths, and many not-so-great ones, were crucified during Area's Religion Night. For some, at least, it was BYO deity. Meanwhile, below, Kenny Scharf plays in his very own room at the Palladium.

conceived by nightclub pros whose aesthetic walks the line between the bar and the cash register. Therein lies the difference between the early art clubs from Mudd through Area and their commercial successors: conception for yucks versus building for bucks. "I used to wonder what it would be like to see art in clubs," muses Jim Fouratt. "Now I wonder what kind of art would be made by artists who didn't go to clubs."

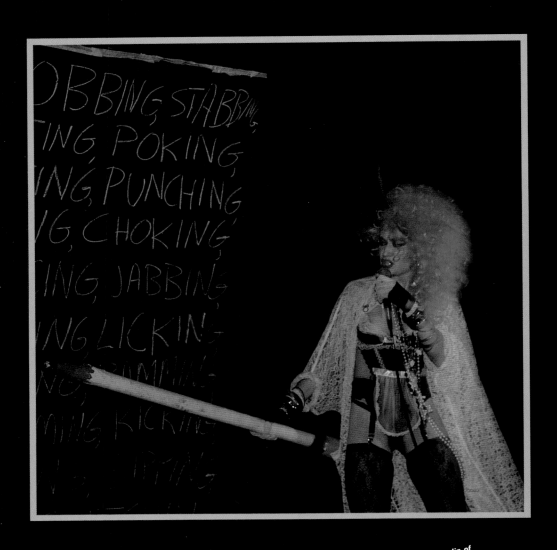

Ann Magnuson, the Lily Tomlin of the East Village, has created a cast of zany characters with which she sends up everything from high society and fine art to hippies and Hollywood. Here, Magnuson, as Madonna knockdown Fallopia, conducts night classes at the Pyramid.

ACTS

David Byrne's success on the rock circuit, built largely on college art students at the beginning, and the international media coverage given to visually oriented performers like Blondie, the Ramones, and Devo, gave rise to the tag "art band." In 1981 Laurie Anderson's "O Superman," issued as a single by the artist's record company, 110 Records, took off on British pop radio. Warner Brothers signed her and sent her deluxe stage show *United States* on tour. Anderson, a veteran of the alternative space and performance festival trail with an underground art reputation, had become a hot media item. These were signals to the following generation that there was a large, paying audience out there for products and entertainment that could also be called art. The stage was set for performance to emerge from the small art venues and audition for the mass audience.

The multimedia performance art of the late 1970s, the staged nature of so much rock music, the example of gay travesty revues, and the late-night antics of the club scene all provided stylistic models. But another source of perception for budding performance artists was more pervasive, having influenced this new generation since birth. It was a source that the previous generation did not quite feel quite comfortable acknowledging: television.

Artists of the '70s had been quick to admit a preoccupation with the movies. Cinema was

75

In late '70s rock 'n' roll, new avant-garde music, art performance, and technology began to combine into a hybrid form of multimedia magic. The presentations of Robert Longo, Laurie Anderson, and even David Byrne, all engaging the talents of many others besides the artists themselves, ushered in an era of collaborative extravaganzas.

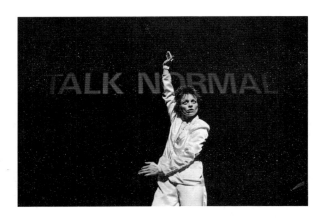

The Somnambulist, a collaboration between John Kelly and artist/set designer Huck Snyder, was presented in 1985 at Limbo, a nightclub turned into a gallery and theater. Loosely based on the German expressionist film classic The Cabinet of Dr. Caligari, The Somnambulist turned Limbo's whole back room into a jagged nightmare world rendered in black and white.

a recognized art form, after all, nothing to be ashamed of being interested in. The whole group of downtown filmmakers connected with the Punk and New Wave scene emerged in great part from this Baby Boom cinemaphilia. But younger artists gradually admitted to one another that they had seen most of their favorite films not at the friendly neighborhood movie theater but on the tube. Furthermore, they came to realize that they had seen everything else on the tube as well: news, variety, domestic comedy, not-so-domestic drama, pretty much everything that made up what they understood to be "life."

McLuhan was right: all of existence is framed by a TV screen. It is not surprising to find an edge of knowing cliché and deliberately stilted fantasy in '80s performance art. This is the shared cultural legacy of hours upon hours spent in front of the tube. As it matures, the work of this new generation's best performers also evinces a sense of critical insight mixed with an awareness of the sheer power of spectacle, enabling these artists to transcend television even as they pay it homage.

Allowed tremendous latitude by the late-night license of the clubs, beginning with her own Club 57, Ann Magnuson has evolved a rogues' gallery of characters and characterizations. Magnuson does not so much command an extraordinary ability to capture personae—although she has acquitted herself admirably in several supporting film roles—as she has an unparalleled gift for inventing them and investing them with highly recognizable, larger-than-life characteristics.

Among the broadly rendered, ever-evolving creatures Magnuson has concocted are Fallopia, sex slave to a Prince-like rock star; Raven, lead singer for the heavy-metal group Vulcan Death Grip; born-again country-and-western chanteuse Tammy Jan; white gospel mama Alice Tully Hall (who carries around husband Avery Fisher Hall's ashes wherever she goes); East Village gallery owner (and, not coincidentally, real estate heiress) Mary Margaret McKeon; terminally tough radical-feminist-lesbian Babe Wrangler; Soviet pop singer Anoushka; and so on.

Although Magnuson limns these apparitions quite vividly by herself, she frequently fleshes them out with a little help from her friends. Raven, after all, sings best with her band backing her, and Alice T. Hall's family accompanies her awfully nicely, thank you.

Ann Magnuson posing as her various personae. Left: The big blue elevator at the Whitney Museum is larger and has better acoustics than most nightclub stages. Ann Magnuson, doyenne of Club 57, took advantage of the facility to do her piece "Upwardly Mobile II," in which she serenaded riders with uncanned Muzak fare.

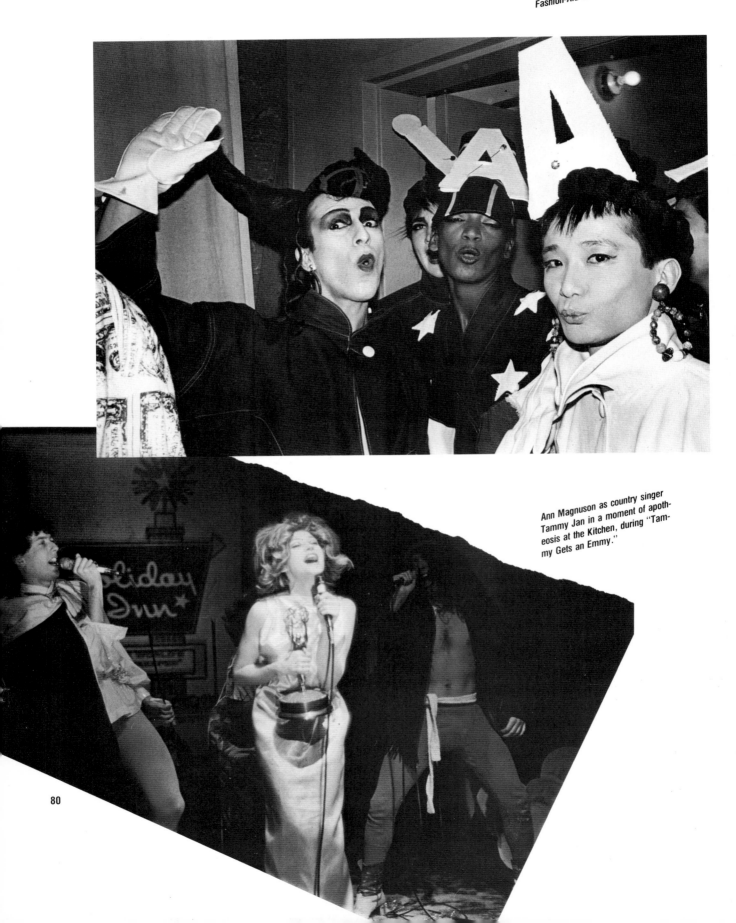

Joey Arias, Ming Vase (a/k/a Benjamin Liu), and festive cohorts strike poses and cop attitudes backstage at Palladium's Fashion-Aid benefit.

Ann Magnuson as country singer Tammy Jan in a moment of apotheosis at the Kitchen, during "Tammy Gets an Emmy."

Magnuson has also teamed with fellow Club 57 alumnus Joey Arias to form The Imitators, a veritable parade of wax-museum figures come to incredibly credible life. Arias as Dali and Magnuson as his paramour Gala, for example; Magnuson playing Squeaky Fromm to Arias's Charles Manson; Joey and Ann doing Andy (Warhol) and Edie (Sedgewick); and other specters of the '60s are resuscitated lovingly, only to be skewered. With appearances in mass-audience magazines and critical lauds for her film roles (in, among other movies, *Desperately Seeking Susan* and *The Hunger*), Ann Magnuson's one-woman ship of fools seems headed for the big time.

The Broadway and "Miami Vice" debuts of Magnuson's one-time underground-comedy partner Eric Bogosian, equipped with a similarly varied bouquet of self-invented characters, indicates that there is plenty of room, and demand, for such offbeat humor. Bogosian's caricatures, however, are not of superstars but of everyday types with everyday names, caricatures to which he brings a pathos and a tragic edge. He creates real people with a ferocious conviction, conveying inner struggles and self-deceptions, while Magnuson aims at media figures, aping and amplifying their mannerisms with the insight of a casting director and the versatility of an improv-troupe veteran. Bogosian's abiding concern with character development is closer to stage drama than is Magnuson's concern with the projection of images, of roles into which human beings have essentially been melted down and remolded. If Bogosian is made for the stage, Magnuson is made from movies and television—and thus for them. Her stated goal is "to have my own TV show which would be a cross between Ernie Kovacs, 'Laugh-In,' and 'Loretta Young Theater.' "

Magnuson's own one-woman gang of characters and her loose, anyone-can-perform attitude spread throughout the downtown scene. Just as the work of Scharf, Haring, and crew added a level of fun and accessibility to '80s art, the presentations of Magnuson, Bogosian, John Sex, Joey Arias, John Kelly, Karen Finley, and the other downtown stars have done the same for performance. Unlike their '70s counterparts, the performers of the '80s are neither academically inclined nor underwritten by grant committees and foundations. John Sex muses that the budget for his events at Club 57 in 1981 was under fifty dollars, while four years later the Palladium paid five

In the late '70s the Kitchen was a hotbed of music-, theater-, and cinema-related performance, thanks to artist-curators like Robert Longo—and Eric Bogosian. As Longo went on to fame and fortune along the gallery route, Bogosian hit the entertainment trail, bringing to Broadway and to television the creeps, wierdos, and other pathetic and pathetically human characters he had first portrayed in downtown performance gigs. Here, Bogosian does Ricky Paul, the quintessential slick party singer-MC who has devastated myriad wedding receptions with his Frank Sinatra tributes.

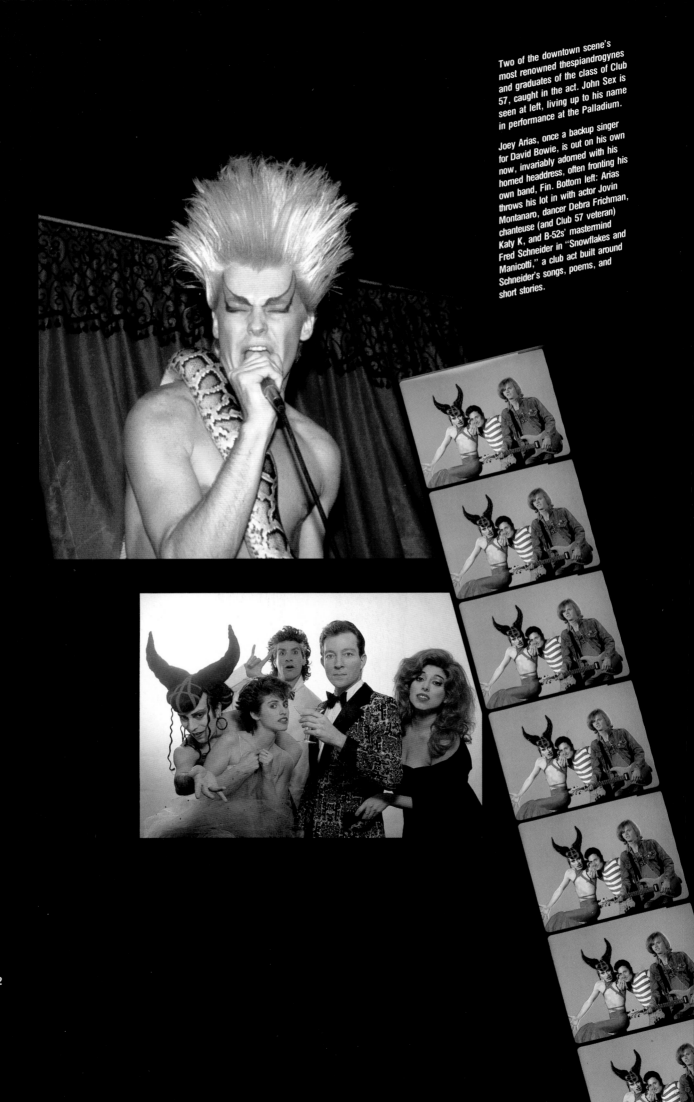

Two of the downtown scene's most renowned thespiandrogynes and graduates of the class of Club 57, caught in the act. John Sex is seen at left, living up to his name in performance at the Palladium.

Joey Arias, once a backup singer for David Bowie, is out on his own now, invariably adorned with his horned headdress, often fronting his own band, Fin. Bottom left: Arias throws his lot in with actor Jovin Montanaro, dancer Debra Frichman, chanteuse (and Club 57 veteran) Katy K, and B-52s' mastermind Fred Schneider in "Snowflakes and Manicotti," a club act built around Schneider's songs, poems, and short stories.

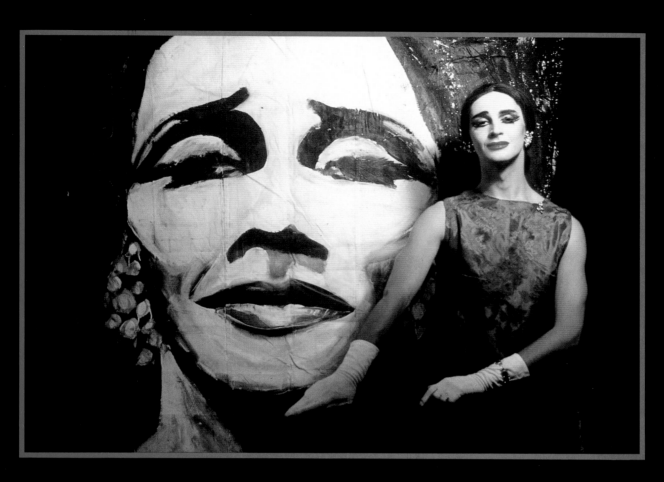

John Kelly's performances range in style and substance from grand opera and mime to vaudeville numbers that would do Milton Berle (or, for that matter, Divine) proud. Kelly's Joni Mitchell imitation always goes over big, thanks not least to his uncanny falsetto, as does his transformation into Dagmar Onassis, replete with to-die gloves and gown.

Tom Murrin, the soi-disant Alien Comic, uses masks and props to enhance his act, while Karen Finley, however fetchingly she may appear here, makes downtown headlines with her raw, intense monologues and graphic, often pointedly disgusting manipulation of food.

Tseng Kwong Chi was the unofficially official photographer of the goings-on at Club 57. Since then, the Hong Kong-born Kwong has trained the camera on himself in his own ongoing photo-performance, "East Meets West." Kwong plays a stolid, gray-suited emissary from the People's Republic of China who visits America's fun spots with all the abandon of a statue.

TSENG KWONG CHI
From the series East Meets West,
1984—85
Black-and-white bromide prints,
each 36 x 36"

thousand dollars just to build the stage for one of his shows. Joey Arias puts it this way: "If we could make the scene we did out of trash and without money, imagine what we can do now. If the world doesn't explode, we will."

One source for the ambition of these new performers, and, indeed, for many of the artists of this generation, has been the cross-fertilization of art and popular music since the mid-'70s. The Punk and New Wave music explosions, so close to the art scene at every turn, lured many of the best artists of the late '70s into bands. The return en masse of many of these to fine art and performance coincides neatly with the coining of the term "art star." In fact, while Byrne summarized the feeling of '70s rock stars about the art world when he said "using the word 'art' tends to scare people away," the rockers of the '80s yearn for the title "artist," or even "artiste," all pretense intended. No one could have dreamed in the '70s that the clubs, whose stages were the exclusive domain of rockers, would feature artists as headliners. Even disco maven Steve Rubell, long clamoring to be seen or photographed with a Rod Stewart or a Michael Jackson at his side, has been quoted as saying that "artists are the new rock stars."

The boundary between art and media entertainment seems fuzzier in the mid-80s than it did in the '70s. To a generation that grew up on TV, this is no more surprising than Jackson Pollock's appearing in *Life* magazine decades earlier. "TV gave us the promise that you could do anything," Ann Magnuson has said. She and her cohorts can often be observed proving it.

Wittiness and witlessness combined in the Club 57 milieu to juice the now-legendary evenings of fraternal fun. Not counting the BYO controlled substances, the budget was approximately $50 a night. Here, Club 57 superstars John Sex and Katy K host the Inaugural Ball, one of Ann Magnuson's theme nights.

Freewheeling humor mixes with anger in the discourses of Karen Finley.

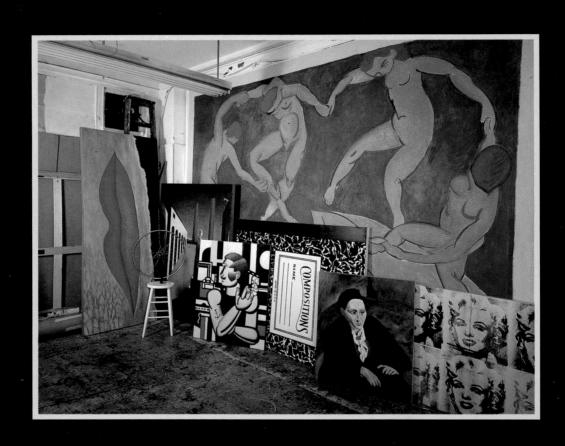

If you didn't know better, you'd think you were in the storeroom at the Museum of Modern Art—although you'd never catch the MOMA crew letting these priceless masterpieces of Modernism stand about casually like this, leaning on each other as if a single artist had just turned them out and left them around his atelier. But that's precisely the case: these are all freshly minted replicas by Mike Bidlo, paintings of paintings seen in the disarray of his studio.

RERUNS

In its day, the critical team of progress and originality served the promotion of modernism as faithfully as the tag "new and different" obliged the marketing of dish detergent, candy bars, and the myriad other products named, advertised, and often created by Madison Avenue in its battle to win the hearts, minds, and money of mass-market audiences. By the end of the 1970s, the ad agencies realized that the psychology of the new was getting old and began their shift toward the current fetishes: all-natural, designer labels, and "real people." Meanwhile, the postwar decades tarnished the twin ideals of progress and originality, as experiments in utopian social planning proved ineffective at best and, at worst, egregiously exploitable. At least since 1940, universal annihilation has seemed more and more probable than universal salvation.

The future of art might better lie in its past. This is a principal belief of the postmodernist outlook, rejecting the notion of aesthetic—or, for that matter, social—progress. But postmodernism does not simply reject progress, allowing for wholesale resuscitation of the past; it encourages critical reconsideration and dissection of this past, particularly of the artistic icons that have symbolized the tenets of modernism. Postmodernism is in effect a revolution, but it is not a revolt. It topples the old order by coolly divesting that order of its authority. In the process, it uses the distance created by time

"I've never felt such an absence of pain."

RICHARD PRINCE
Joke, 1985
Pencil on paper, 40 x 26"

and change of social context to show us how that order's icons and ideas functioned as its propaganda, and what, by contrast, they mean to us, in our changed context. In essence, we find that the art of any era viewed out of its context allows us to understand the art, the context, and our derivative relationship to both.

Besides the idea of progress, the modernist notion that postmodernists have subjected most harshly to critical dissection is that of originality. Western society no longer exhibits the resistance to new ideas that made an avant-garde possible in the nineteenth and early twentieth centuries. Thus artists cannot position themselves effectively against social norms without quickly being absorbed by those norms. New art forms and movements once took years to sway younger generations even as they shocked older ones. Now new forms and movements have instant influence—and have had such influence since the mid-'60s. Pop Art, attacked in 1962 as phony, was reshaping fashion and advertising design by 1965. The recognition that the mass culture could effectively absorb the avant-garde for economic gain—"radical chic" was the slogan that was coined—veritably ended the notion of avant-garde. From then on, no matter how radical, new artistic developments enjoyed, or suffered, substantial acceptance as soon as they appeared.

Social acceptance of the new, however, was, and remains, only skin deep. We are still a conservative culture, addicted to the status quo. The acceleration of fundamental change in our reception of the world, part and parcel of our changeover from a mechanical to an electronic society, only instills a sense of loss for what we understand as middle-class verities. We respond not by changing our thinking but by embracing nostalgia and having revivals of bygone eras. Everything old is "new" again. But something is only new once. When it reappears, *it* is not new, the context in which it turns up is.

In the Class of 1978 there were more than a few artists who both criticized modernism and perceived the basic conservatism of a public at large supposedly converted by (or born into) modernism. They recognized that the unwittingly hypocritical stance of modernism was rendering the public passive in the face of vast social manipulation, through fine art and communications media alike. Instead of joining the public in their hypocrisy, as the Neo-

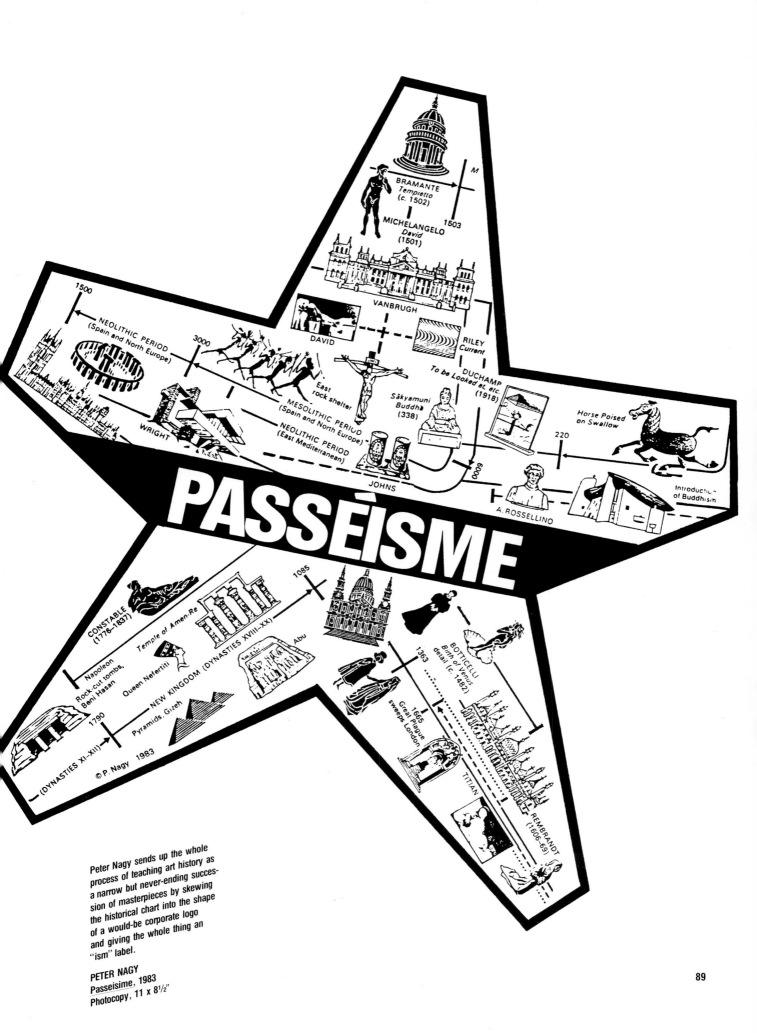

Peter Nagy sends up the whole
process of teaching art history as
a narrow but never-ending succes-
sion of masterpieces by skewing
the historical chart into the shape
of a would-be corporate logo
and giving the whole thing an
"ism" label.

PETER NAGY
Passeisme, 1983
Photocopy, 11 x 8½"

89

JULIE WACHTEL
Perspective of Reference, 1984
Oil on canvas, 114 x 30"

Expressionists were doing, these other artists took a different tack.

Artists like Longo, Goldstein, Levine, and others included in the landmark *Pictures* show began a body of work and a new tradition that aped and reconstituted the visual and material conceits of the media. There was something Pop Art about this attitude and in the look of their work. But there was something else as well, an implicit critique of both passively received art history and passively received commercial messages. Through disjuncture, excerption, pointed juxtaposition, exaggeration of mannerism, and the isolation of objects from purported use, these artists mock the pretensions and unmask the manipulative nature of the message-bearing images fed us through various media and designed to keep us consuming goods, goods produced solely to be consumed. The result is not only an appropriation of imagery but also an appropriation of the power of that imagery.

Artists involved in appropriation are now numerous. Indeed, it can be said that appropriation art is one of the most significant contributions of the East Village ferment to contemporary art. Peter Nagy's real and imagined corporate logos, magazine ads excerpted by Richard Prince, Howard Halle's slightly altered political cartoons, the greeting-card paintings of Julie Wachtel, Vikki Alexander's contact-paper installations, Alan Belcher's sandwiched photo-images, and a host of artworks made of advertising slogans, assembly diagrams, newspaper photographs, and all kinds of banal images, once familiar to the point of invisibility, now incongruously occupy prominent galleries, forcing viewers to reevaluate their original contexts and original messages.

Clearly, this is a socially aware and intellectually rationalized strategy, at its best combining the judiciousness of a diamond merchant with the jaundiced outlook of a journalist and the analytical distance of a sociologist, wrapping the whole in a sheath of intricate philosophical rationale. Such intellection must, for instance, substantiate the found-object, or more accurately, *bought*-object, sculpture of Haim Steinbach and Jeff Koons, lest the impact of their work dissipate into show-and-tell. Koons cannot simply present two basketballs floating in a tank of water, or a pristine new vacuum cleaner encased in a Plexiglas box, as Duchampian readymades. Steinbach cannot display lava lamps, digital

Gretchen Bender's arrangements of reproduced works by her contemporaries argue with the Modernist idea of originality. She drives home her argument by conjoining the reproductions with a fashion photograph that would seem to be a combination of the two artworks—two Robert Longo women wearing Sol LeWitt stripes.

GRETCHEN BENDER
Untitled, from the series, The Pleasure Is Back, 1982
Four silkscreens on tin, overall size approximately 72 x 72"

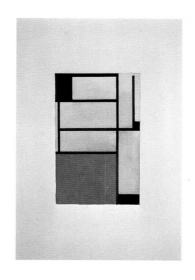

After the photographs of photographs, Sherrie Levine did a series of watercolors, reproducing already extant artworks as exactly as possible. It was not, however, the artworks themselves Levine sought to reproduce, but their reproductions in postcard form. Thus, this After Mondrian is a painting of a postcard of a painting. And, of course, its reproduction here is a reproduction of a copy of a reproduction of an original. . . .

SHERRIE LEVINE
After Walker Evans, 1981
Black-and-white photograph, 10 x 8"

After Mondrian, 1983
Watercolor on paper, 14 × 11"

Sherrie Levine takes Bender's argument a step further. Here, she has taken a photograph of a photograph. The result seems to be simply the original Evans photograph. But it isn't. That is, it could be, as a recognized image, but in this context it couldn't be the . . . oh, never mind.

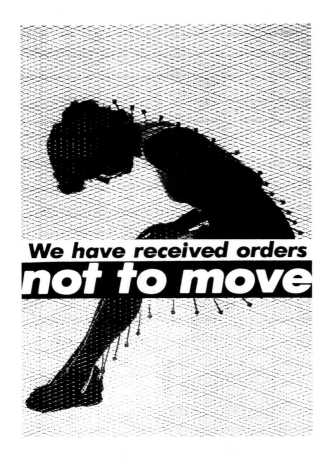

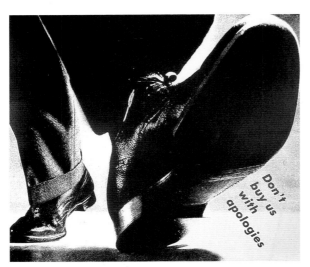

BARBARA KRUGER
Untitled, 1982
Black-and-white photograph, 72 x 48"

Don't buy us with your apologies, 1986
Color photograph, 48 × 62"

Untitled (We are your circumstan-tial evidence), 1983
Black-and-white photograph, 72 x 48"

bedside alarm clocks, Star Wars character masks, or Nike hi-top sneakers as abstract sculptural forms. Koons isolates his "useful" consumer items in a way that vitiates their use and underscores their fetishistic appeal. Stein-bach suspends his own choices of current consumer-oriented objects between fetish and assembly-line ordinariness, maintaining this suspension by displaying two of each item.

The work of Barbara Kruger stands at a bit of a remove from the conscious plagiarism of other appropriators. Where the others deliber-ately minimize changes, Kruger thoroughly transforms her source material. Indeed, Kruger does not wish to evince her sources, only to mimic them. Her use of billboard-size photographic imagery, montaged with text, quickly recalls outdoor advertising. But the images and texts themselves sure don't, except in their caustic references to social manipulation.

Kruger's message—often feminist and usually ominous and double-edged—is one of declaration, not simple example. In this re-spect it is similar in spirit to the work of Colab stalwarts like Rebecca Howland, Jenny Hol-zer, and Mike Glier. Kruger creates slogans of powerful symmetry and lyricism: "We won't play nature to your culture." She wrests fur-ther impact from her unexpected conjunc-tions of word and image, as in the photograph of a plate of rich pastries overlaid with the de-mand "Give me all you've got"—the salacious turned into the gluttonous—or the golf green accompanied by the phrase "We are your com-plicated holes"—the banal turned into the lewdly challenging. Kruger is a poetic master of the verbal-visual double entendre, and unusual among appropriators in her active intervention in and manipulation of the source material. Passive subversion, Kruger shows, is not the only appropriate—or appropriated— weapon.

The strategies of those appropriation art-ists who would upend our fetishization of fine art depend on a different kind of recognizabil-ity. While consumer depropagandists like Nagy and Wachtel set commercial images off in ironic contexts and commodity breakers Steinbach and Koons incorporate objects into their own demystification, artists like Louise Lawler and Philip Taaffe, Allan McCollum and Sherrie Levine, Gretchen Bender and Mike Bidlo, critique that bugbear notion of originality, the fetishization of purported "masterpieces" it brings about, and the dis-

We are your circumstantial evidence

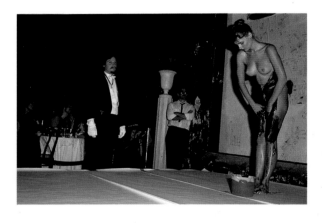

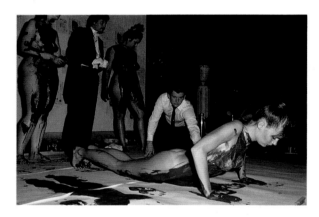

tance such masterpieces actually maintain from the experience of most people.

Sherrie Levine, particularly, examines what Walter Benjamin saw as the crisis of "art in the age of mechanical reproduction." Her photographs of photographs question the nature of photographic "originality" by sending the whole issue hurtling through a hall of mirrors. Meanwhile, her painstaking hand copies of postcard reproductions of works by Léger, Malevich, Mondrian, and other twentieth-century heavies ironically reintroduce the manual touch—the "human flaw"—into mass-market versions of one-of-a-kind pictures. Where are the masterpieces anymore?

Gretchen Bender, by contrast, questions the media-induced process of instant masterpiecehood that occurs when an artistic image is given currency and even permanence through widespread dissemination. Her one person show of December 1983, entitled *Change Your Art*, consisted solely of works appropriated from her contemporaries, notably Longo, Schnabel, Salle, and Haring. "I purposefully chose the images that were most reproduced in the art press and newspapers," says Bender. "I wanted people to take a second look, to expand their vision of each piece so that they could experience art as communication rather than as commodity." In her tastefully arranged shows of appropriated work, questions of masterpiecehood and monumentality collapse into questions of originality.

Mike Bidlo's obsession with meticulous reproduction has singled him out as the most controversial of the appropriators. His critics, including many fellow appropriators, complain that Bidlo's work has broken the gossamer barrier between appropriation and forgery, disqualifying itself as art. In fact, he does go to great lengths to reconstruct his chosen subjects as accurately as possible. "When I was a kid," Bidlo says with a smile, "I used to love to use tracing paper. And I always found forgery fascinating, whether it was art or printing money."

Bidlo's work transforms the fetish of originality into the fetish of replication—the oxymoronic "original copy" made flesh. He has refabricated Warhols, Pollocks, Brancusis, Légers, Matisses, Kleins, Cézannes, and numerous other modern museum pieces and auction-house goodies. Several major collectors of abstract expressionism have displayed his Pollocks prominently among their "origi-

nal" de Koonings, Hofmanns, and, indeed, Pollocks. In a rare reversion to a contemporary work, Bidlo reconstructed the Schnabel painting that brought a whopping $93,000 at auction and exhibited the reconstruction at P.S. 1 not long after the auction itself—complete with floodlights, velvet rope, and armed guard. The presentation took on a circus atmosphere, adding a performer's flair to the commentary of the painted construct. In this way, Bidlo has brought to the art world not only re-created masterpieces but something like an intellectual version of stand-up comedy.

Bidlo has been accused of lacking other appropriationists' irony, replacing it with a simple sense of entertainment. Next to cerebral appropriators like Kruger or obliquely sardonic ones like Bender, it is true, Bidlo does seem awfully direct and unmediated. His reconstructions of some "great moments" in recent art history—Yves Klein's public painting-performance where live nudes were used as paintbrushes, or events in Andy Warhol's Factory, or Pollock's piss into Peggy Guggenheim's fireplace—have an aura of dress-up fantasy, at least in the retelling. But the exactitude with which Bidlo has realized all these events, his presentation of them not simply as dressing-up-like-daddy travesties but as examinations of the power these legendary events

Mike Bidlo's appropriation of art history is not simply a gambit for churning out obvious forgeries. He is out to examine, celebrate, and at the same time deflate the legendary objects and apocryphal events of modern art history, the ones from which art students get their jollies. Bidlo thus reperforms events as well as recreates artworks. Above: One result of Bidlo's recreation of the Jackson Pollock myth.

MIKE BIDLO
Convergence, 1985
Enamel on canvas, 110 x 82"

exert over our understanding of recent art, be-
lies any frivolity in the concept or the effort.
And, for Bidlo, if his art is fun, so much the
better. "All good art becomes entertainment,"
he says with a shrug, "whether it's a great
movie or the Metropolitan on Sunday after-
noon. I dislike egghead art that hangs hermet-
ically on the wall. Art needs a sense of Dada,
a little humor alongside its intelligence."

 Bidlo would effect a paraphrase of Marx's
famous dictum: art history repeats itself, the
second time as art. Is there a third time? "I
think," Bidlo states with obvious distaste, "that
it would be really boring to appropriate my
work. Copying the copy? That doesn't work
for me."

 What about the reruns?

"It's a really cool thing to drive," Kenny Scharf says of his customized Cadillac. "No matter where you go, everybody looks at you and waves." You bet they do—especially if you've got a customized character like Ann Magnuson in the front seat with you.

KENNY SCHARF
Ultima Suprema Deluxa, 1984
Acrylic, spray paint, found objects
on 1961 Cadillac

KICKS

"**A** dream I've had for quite a while," says Kenny Scharf as he puts the finishing touches on a line of silk sweaters he's been commissioned to handpaint, "is to have a traveling art circus. I'd drive up in my custom Cadillac hooked to a customized trailer with a built-in stage. Every town we played in Keith [Haring] and I could do mural commissions in. We'd show the kids how to make art and document it all on film. Then at the end I'd park it in a cool place and build a giant amusement park."

"Fun" is Scharf's byword, but he shares the Fun Art arena with an increasing number of artists, including Keith Haring, Ronnie Cutrone, Dan Friedman, Rodney Alan Greenblat, and Rhonda Zwillinger, who have habituated art and general audiences alike to the notion that art can be fun. The cartoon edge of these artists, largely derived from a '60s TV aesthetic, makes their work at once popular and populist and has animated the art scene with bright colors, zany humor, and almost childlike imagination.

Scharf is your quintessential LA party boy, the type you can imagine drawing Fred Flintstone on the cover of his high school history book. He doesn't try to play the Eastern intellectual art-rap game or let such concerns dull his Day-Glo style. His studio, with a huge two-headed icon of good and evil looming from the ceiling, can't help but remind you of a fun

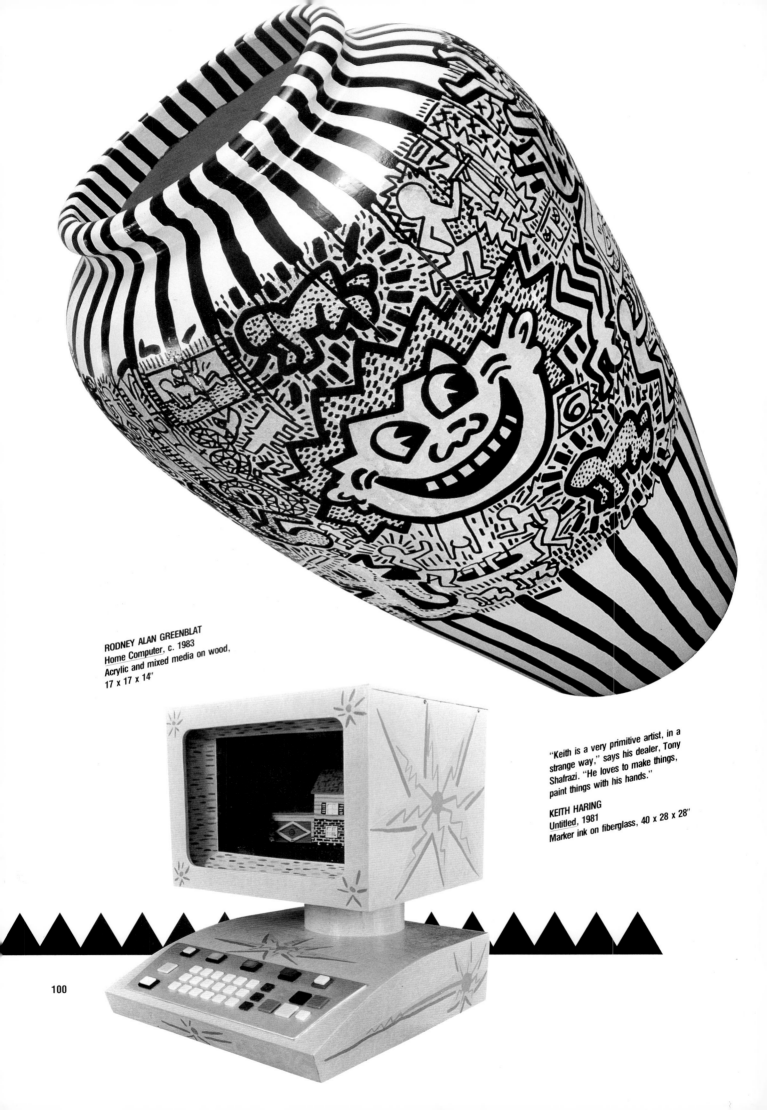

RODNEY ALAN GREENBLAT
Home Computer, c. 1983
Acrylic and mixed media on wood,
17 x 17 x 14"

"Keith is a very primitive artist, in a strange way," says his dealer, Tony Shafrazi. "He loves to make things, paint things with his hands."

KEITH HARING
Untitled, 1981
Marker ink on fiberglass, 40 x 28 x 28"

house. "I never preplan my work," Scharf says nonchalantly, as he sits in his plastic amoeba mold chair and listens to vintage T-Rex blare from his customized blast box. "I work everything out visually as I go along. If I make a mistake, I just blend it until it isn't a mistake anymore."

Scharf effects no critical distancing whatsoever and exercises no socially pointed recontextualization of the cartoon characters he paints into his psychedelic science fiction scenes. He simply keeps on paying his homage to George Jetson, Wilma Flintstone, and other apparitions from a cartoon-filled childhood, extending their influence into a cartoon-filled adulthood. Puzzlingly intellectual reviews of Scharf's work are as useful as a deep, philosophical analysis of the Three Stooges. "Social commentary isn't Kenny's thing," explains his longtime friend John Sex. "He's into painting and having fun."

Ronnie Cutrone's contribution to Fun Art derives its popular appeal in large part from Pop Art. Cutrone was a former studio assistant in Warhol's Factory, pulling silkscreens and shooting the photographs for several of Andy's more controversial works, such as the skull series. In his own work, Cutrone appropriates widely recognized cartoon characters—Woody Woodpecker, Tweety Pie, Mighty Mouse—into a conceptually freewheeling but visually hieratic, even iconic, pictorial schema. Cutrone's painting-collages and drawings invest unlikely subjects like Sylvester the Cat and Casper the Friendly Ghost with political portent, driving the point home by surrounding the comic book cast with forceful indicators such as burning flags, instruments of war, and thrift-store paintings on black velvet, altered to address contemporary issues.

Cutrone's appropriative methods and the messages he seeks to convey with them are not overly concerned with intellectual sophistication. Rather, Cutrone wishes to speak from—and to—an essentially populist viewpoint. His paintings are in effect political cartoons, powered by their easily understood imagery, their physical largeness, and their relative crudity. Cutrone does not render these figures with critical distance but rather with a childlike empathy. His cartoon characters—as central to the childhood mythology of Cutrone's generation as Big Bird and the Cookie Monster are to the mythology of today's children—still resonate with the benign power of homily-laden fantasy.

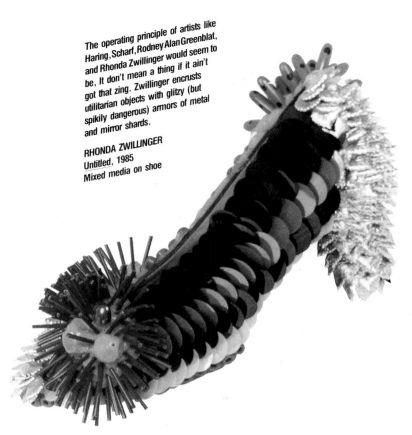

The operating principle of artists like Haring, Scharf, Rodney Alan Greenblat, and Rhonda Zwillinger would seem to be, It don't mean a thing if it ain't got that zing. Zwillinger encrusts utilitarian objects with glitzy (but spikily dangerous) armors of metal and mirror shards.

RHONDA ZWILLINGER
Untitled, 1985
Mixed media on shoe

While Haring was covering subway walls with his chalk drawings, Ronnie Cutrone was also resorting to chalk on occasion, as in this evocation of elementary-school ambience and emotion.

RONNIE CUTRONE
School Is Out (front view), 1983
Chalk, marker, and acrylic on blackboard, 72 x 72"

KENNY SCHARF
Major Blast, 1984
Oil and spray paint on canvas,
96 x 96"

Kenny Scharf has gotten a good
deal of mileage out of operating on
a high-energy version of the Pleasure
Principle. For art-world sourpusses
who cavil at the thought of Scharf
giggling all the way to the bank, his
extravagant painted installation at
the 1983 Whitney Museum Biennial
of American Art was a particular af-
front. Predictably, however, the in-
stallation was the popular hit of
the show.

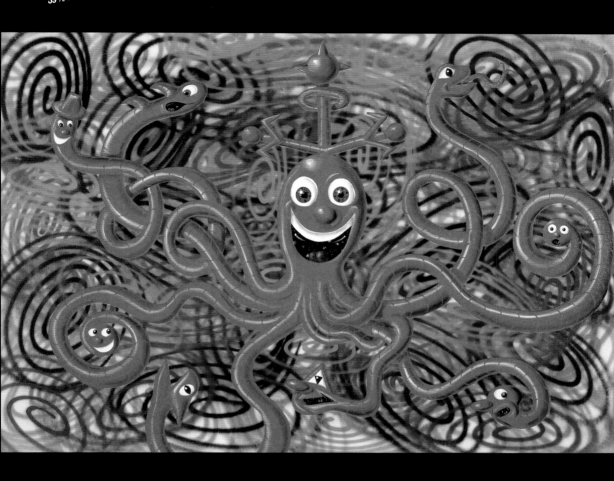

Controlopuss, 1983–84
Oil and spray paint on canvas,
59½ x 84"

RONNIE CUTRONE
Fruits of the Spirit, 1982
Acrylic on rayon flag, 120 x 72"

Scharf's friend and comrade-in-fun, Keith Haring, may well be the artist most responsible for the recent explosion of Fun Art. Haring evinced his sense of humor and his flair for attracting attention while still a student, doing things like having his friends customize his eyeglasses, embellishing them with everything from zebra fur to stars and stripes. With a real-life character like Haring as its most visible figure, it is no wonder that the '80s scene has developed such a prominent funny bone.

By 1981 Haring had fully formulated his starkly linear style and had begun to evolve his iconography accordingly. The substance and reasoning behind this iconography, less self-indulgent than Scharf's and less naive than Cutrone's, depend both on personalized imagery and on a direct, passionate comprehension of current political and social events. Double meanings and symbolic ambiguities abound. The famous "radiant child," for example, can be read as a warning against nuclear power or as a reaffirmation of the common individual's inherent vibrancy. The winged TV set may be indicative of television's ability to span great distances but also of its coopting the "wings" of individual imagination. The dog-headed man doubles as a symbol of the power of the animal kingdom and of the animalistic instincts in humans. These interpretations may be contradictory, but, in Haring's radically simplified style and vocabulary of images, they are difficult neither to grasp nor to formulate. Not only are his style and imagery fun to look at, but the process of interpreting that imagery is inherently playful.

Many artists, from Paul Klee to Jean Dubuffet, from Pierre Alechinsky (whom Haring cites as an influence) to Anton van Dalen, have worked successfully with such a finely honed language of easily understood ciphers. But Haring has gone further in disseminating his art. He has made his imagery eminently available, in the subways and out, putting it on everything from walls to lapel buttons, and often giving it away or donating it to charitable causes. Haring's munificence has been mistrusted by those who begrudge him his success, and its role in that success cannot be denied. But neither can its sincerity, given Haring's well-known involvement with social causes and his long-standing commitment to sharing his vision. Even though he has arrogated some of the commercial potential of his work to himself by opening up his Pop

RONNIE CUTRONE
Evolution, 1983
Acrylic on rayon flag, 72 x 120″

Amore, When the Moon Hits Your
Eye Like a Big Pizza Pie, 1982
Acrylic on rayon flag, 60 × 96″

RONNIE CUTRONE
Idolatry, 1984
Acrylic on collage, 49 x 35″

Just because an artist creates Fun
Art, or incorporates fun images in
his or her art, doesn't mean that life
for that artist is one long hoot.
"People expect me to be cold and
calculating because I worked for
Warhol for so long," complains Cu-
trone. "Actually, if it weren't for my
belief in God and prayer every day,
I never could have gotten through
the rough stages of being an artist,
being poor and confused. . . .".

Tribute to Laverne, 1983
Mixed media on fabric. 96 x 216"

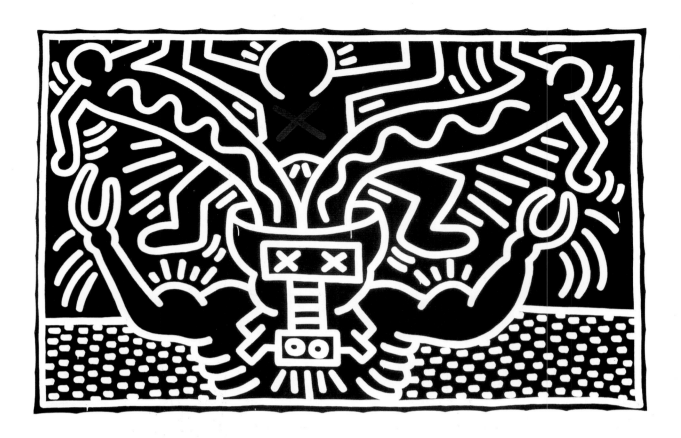

Shop, Haring comes off less a trinket-hawker or politician than he does as a kind of art-world Santa Claus, eager to bring the gift of fun to all.

What constitutes fun from a middlebrow urban-American outlook is not simply pictures but objects, games, events, toys. Even adults have toys, whether they be of an innocent, playful nature or—like cars or even guns—have primary uses augmented by sportive ones. In New York, as in most urban settings, one sees evidence of this especially in non-Anglo working-class neighborhoods, where implements that imbue their owners with status, like cars or sound equipment, are aggrandized through "customizing." Kids customize their bikes and skateboards, adults customize their cars and motorcycles. Haring, Scharf, and other downtown artists customize objects galore, festooning everything from telephones to Cadillacs with fanciful extensions of their normal mannerisms.

This practice is part and parcel of the American artist's abiding responsivity to vernacular modes of expression. One might say that that responsivity—that willingness to look beyond issues of good and bad taste to an apprehension of simple authenticity—is one of the principal characteristics of American

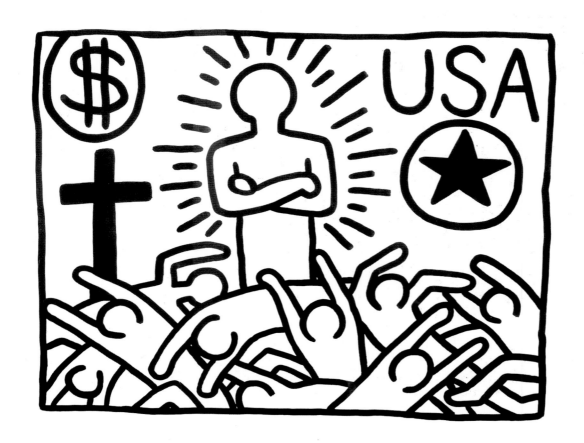

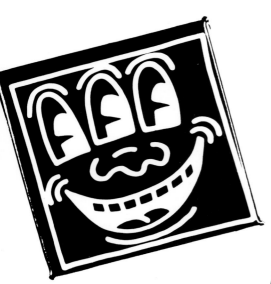

The Keith Haring "look," one part Paul Klee, one part graphic design, and one part doodle, has captured the visual imagination of the country— and, with the marketing of everything Haring from lapel buttons to Swatches, is spreading his signatory images (the Barking Dog, the Radiant Child) throughout the world. Haring hopes not only to make a bundle through this dissemination, but to influence public opinion about pressing issues like nuclear power and AIDS.

109

However vast and ambitious his
work gets, however, Haring never
loses sight of its basic strength: his
firm, sinuous line, rendered clearly
against contrasting grounds.

KEITH HARING
Untitled, 1986
Acrylic and oil on canvas, 96 x 144"

Untitled, 1986
Acrylic and oil on canvas, 96 x 120"

Installation, Tony Shafrazi Gallery, 1984

·aesthetic perception. American artists do not
simply cherish the folk and vernacular arts of
their country, they use them. Artists in this
country are continually fascinated by Outsider
Art—the art of the untrained, of children,
even of the insane.

In New York, capital of High Culture,
there was long a European-type resistance to
the vernacular. This began to erode in the
1970s, however, especially as non–New York
art styles began to clamor for attention, and
as a new generation of artists, responsive to
stimuli as varied as van Gogh and graffiti,
Caravaggio and Canal Street, Degas and Deco,
Hiroshige and Head Comix, entered the scene.
The women's movement provoked interest in
traditional decorative arts, and growing curi-
osity about non-Western cultures—Islamic,
Latin, Indian, African—gave rise to a new ap-
preciation for patterning. By the mid-'70s the
minimalist grid was bedecked with curlicues,
floral motifs, little figurines, and a rainbow of
colors; and by 1980 painters like Robert Kush-
ner were having their own fashion shows,
sculptors like Thomas Lanigan-Schmidt were
exhibiting ornate shrines made from tinsel
and tinfoil, and a whole clutch of sculptors
was prowling Canal Street looking for discard-
ed plastics and cheap electrical gadgets to
make into eccentric forms.

The customizing practices of the Club 57
crew were part and parcel of this new démodé
opulence. One of the less-regular regulars at
Club 57 was Dan Friedman, an artist and art
director whom Tseng Kwong Chi had intro-
duced to the place. Friedman, who was older
than most of the club's clientele and whose
professional design career was already fairly
established, did not feel entirely cozy in Club
57's manic milieu. He was nonetheless af-
fected by the club's giddy spirit and soon
embarked on a kitsch-influenced style of
sculpture and interior design, making uninhi-
bited use of cheap materials, found objects,
garish colors, explosive forms, and outré ef-
fects like black light and motorized parts. In
his interiors and ornate sculptures especially,
Friedman defines the parameters of the Fun
aesthetic.

Friedman also participates in an interna-
tional tendency that the French call bricolage,
meaning inventive handiwork, or tinkering.
Although integral to the thrifty, inventive, and
slightly eccentric American vernacular ethos,
bricolage has manifested itself strongly
throughout the art world. There is a spare-

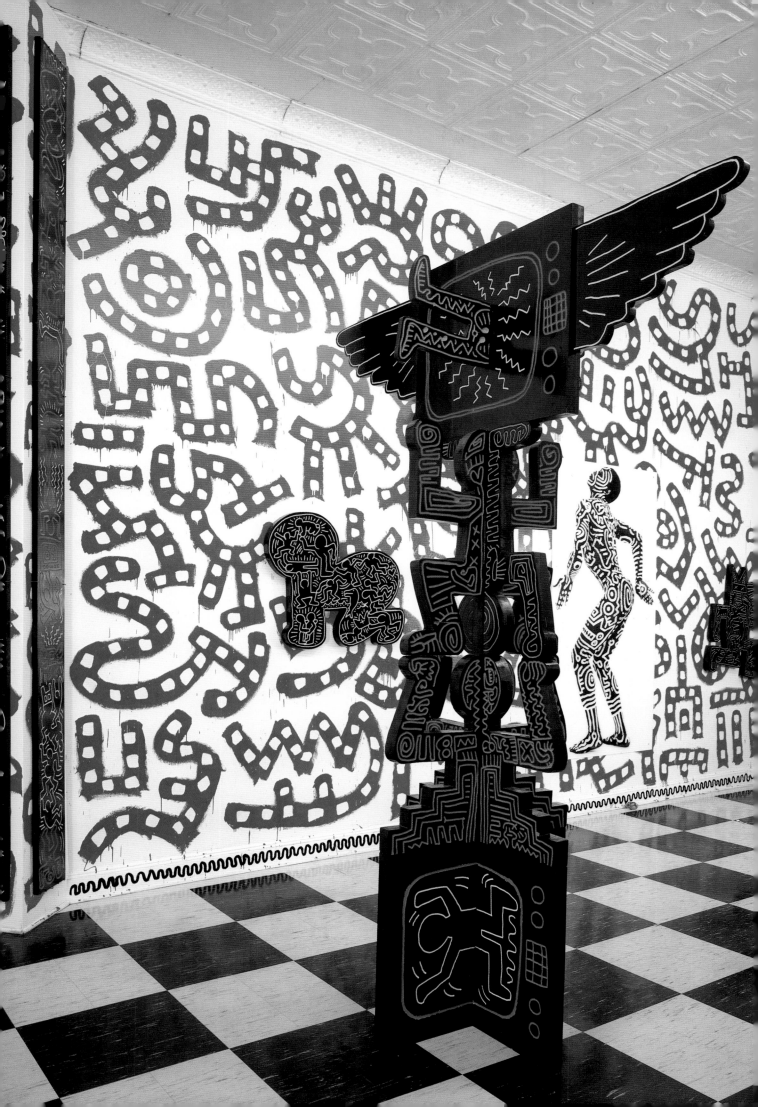

part aesthetic at the heart of the new sculpture now all the rage in Europe, sculpture that is assembled from crafted units, quasi-architectural details, and found objects; and bricolage is at the heart of that aesthetic. French sculptors, not surprisingly, are especially involved in bricolage; a number of English sculptors are also active; and the tendency is evident in new sculptural work from northern and central Europe as well. In New York, Friedman is hardly the lone bricoleur. Veterans of the "Canal Street School" like Taro Suzuki and Nancy Arlen are relatively old hands at the practice and are being joined by tinkerers like TODT, a collective specializing in gruesomely clever objects and installations tinged with social commentary. Kathleen Thomas creates sleek and dangerous-looking little ray guns and mysterious minimachines from discarded spark plugs, plastic containers, and other contemporary detritus. Jon Kessler's elaborate shadow boxes, replete with moving parts and intricate lighting cycles, have been growing larger and larger, climbing off the wall and onto the floor.

Rhonda Zwillinger, too, can be regarded as a downtown bricoleuse. Known for customizing everything from picture frames to grand pianos with encrustations of costume jewelry, shards of broken mirror, and anything else that glitters but is not gold, Zwillinger, like Friedman, is clearly in it for the fun—for herself and others. "I like using symbology that can reach out beyond the connoisseur crowd," Zwillinger states. "One of my biggest goals is to reach the masses with my work, to do for art what rock 'n' roll did for music."

There is less concentration on assemblage and more on straight fabrication in the work of Rodney Alan Greenblat, but he too has incorporated prefabricated objects into his tableaux. Greenblat, in fact, made his big New York splash with a diorama-like construction adorned with cartoony depictions of a South Sea paradise and dominated by a full-size boat rocking back and forth like a kiddy ride in a shopping center. Since then, both those cartoony depictions and the use of extant objects have proliferated in Greenblat's jocular work, although he now builds most of his own structures.

Fun is busting out all over. It is to be found in Dan Freeman's comic-strip-like paintings of urban narratives (often illustrating stories by his writer friends) and in the "win a trip to Paris" contest held by Mike Howard as an in-

If Fun Art has its carefree side and its stoned-out side, it also has its nasty, fetishistic side. Personal obsessions and childhood memories recur in some nominally Fun art, while ecological problems are rued through satire in others. Even dead-baby jokes can be turned into dresses, given the right sensibility.

PEGGY CYPHERS
Nesting Fossils, 1984
Acrylic on canvas, 56 x 50"

CHRISTY RUPP
PCBs in the Hudson, c. 1982
Oil on aluminum and steel

HUCK SNYDER
Dress, 1986
Acrylic on fabric

113

RODNEY ALAN GREENBLAT
Ark of Triumph, 1984–85
110 x 116 x 24"

KENNY SCHARF
Extravaganza TV, 1984
Acrylic and assemblage on TV set,
acrylic on chair, 36 x 20 x 36"

DAN FRIEDMAN
Krishna Korner, 1986
Mixed media

MICHAEL CLARK
Club Land, 1984–85
Oil and mixed media on wood,
24 x 24"

RHONDA ZWILLINGER
The Promise, 1985
Oil on canvas, 45 x 70 x 2¹/₂"

116

Among the stock images that brought attention to Mark Kostabi were his wittily surreal depictions of boardroom meetings, sly metaphors for the human—especially white-collar urban human—situation. Often criticized for his simple, cartoonlike style and themes, Kostabi retorts, "In a world of spaceships, what would you rather have at the controls, a steady hand or that of some sloppy expressionist?"

MARK KOSTABI
Various drawings from Upheaval

There is some Fun Art you don't just go and see—it comes to you or you don't see it. This startling apparition led the 1986 version of the Halloween parade that fills Greenwich Village streets every year.

ERIC STALLER
Bicyclists, 1986

tegral part—indeed, the central theme—of his one-man show at Gracie Mansion. It is evident in the melodramatic paintings of Keiko Bonk laden with pulpy kitsch images of embracing couples, religious symbols, peace signs, and rocket ships, and in the virtuoso circus motifs and stage sets of painter Huck Snyder. It is in the gawky bricolaged lamps of R. M. Fischer and in the busy-looking but useless machines of Dean McNeil. It can be had with the chiming pinball machines and other sonic game devices of Bill and Mary Buchen, and in the three-dimensional objects covered with musical notation (and often producing music) by William Hellermann.

If life is a movie, art can be an animated cartoon, complete with mass-media audience. Tricks, after all, are not just for kids.

A world suffused with art, whether
made possible through the efforts
of a single shop or thousands of
artists creating utilitarian objects
and designing products, now
seems less a fantasy than a
necessity. Of course, the mass-
consumption version of this
waking dream will have to be
honed down a bit from the high
pitch of this bristling installation
by Rhonda Zwillinger.

RHONDA ZWILLINGER
Post Minimal Glitz, 1985
Installation at Gracie Mansion
Gallery

OBJECTS

The Museum of Modern Art had an architecture-and-design department when it opened in 1929; many other museums followed suit, and many more without design collections of their own have mounted shows of design, averring to aesthetic continuities between the functional objects on display and the fine-art objects under the same roof. But such establishments have tended to keep the fine and the functional segregated, separate, and (less frequently) equal. This distinction between art and design is one more traditional boundary that the new generation of artists, designers, dealers, and collectors is rethinking or even ignoring. As Holly Solomon, one of the first dealers to show artists' furniture, explains, "The artists have gotten bored with useless objects and have found a new frontier in furniture. At the same time architects are becoming free of the stringencies of usefulness and feel more comfortable with pure design." When artists cross the border into areas that used to be the province of design and when commercially and functionally minded talents claim the prerogatives of artists, a new world of objects comes into being. It is a world of artist-designed T-shirts and collectible shopping bags, a world whose inhabitants live in homes furnished with zany sculpted chairs and painted tables and drive customized cars down to the local art shop.

Artists' furniture is not a new concept, but

119

DAN FRIEDMAN
Ceremonial Screen, c. 1985
Assemblage

E.B. JACKSON
Gloria, 1983
Fiberglass and aluminum

what is new is the sheer number of people now actively and passionately involved with objects created by artists, whether as makers, dealers, or buyers. One can point to a solid economy, a status-conscious society, or even a decade of art trends as reasons for this phenomenon. But these explanations overlook the fact that the artists who have turned to the design field are creating works that are also first-rate products, objects eagerly welcomed into the new urban homes of the last fifteen years—humorous chairs, sculptural couches, whimsical tables, and ironic lamps that serve their mundane functions while adding individuality and energy to the anonymous interiors of modern apartments and former commercial spaces.

Of the many artists, designers, dealers, and collectors involved in the current wave of artists' furniture, Rick Kaufmann is certainly a pivotal figure. A former antiques dealer, Kaufmann opened a store gallery-showroom-workshop called Art et Industrie in December of 1977. "With objects," explains Kaufmann, "I knew people expected me to pigeonhole the work as art/sculpture or furnishings. I was more interested in eliciting emotions than praise, so I thought that the mixed message was the best message." A varied and interesting range of people responded to Kaufmann's message, and within a few weeks he was besieged with offers, requests, and questions from painters, sculptors, industrial designers, furniture designers, architects, craftsmen, and generally confused but intrigued others who made Art et Industrie the locus for a new medium.

Over the next few years, Kaufmann exhibited radical forms of design ranging from High Tech, complete with his "Hi Tech Manifesto," to the colorful, eccentric renderings of the Memphis Design Group, which got its first American exposure at Art et Industrie. Kaufmann's gallery was also the first furniture showroom for artists' furniture. At the beginning, he exhibited hardly functional items by the likes of Richard Artschwager and Lucas Samaras. Within months, however, his policy had evolved toward functional design as practiced by sculptors R. M. Fischer and Forrest Myers, furniture designers Howard Meister and Dakota Jackson, craft artist Elizabeth Jackson, and architects James Evanson and James Hong. The question whether this work was art or furniture remained, but function united Kaufmann's core group.

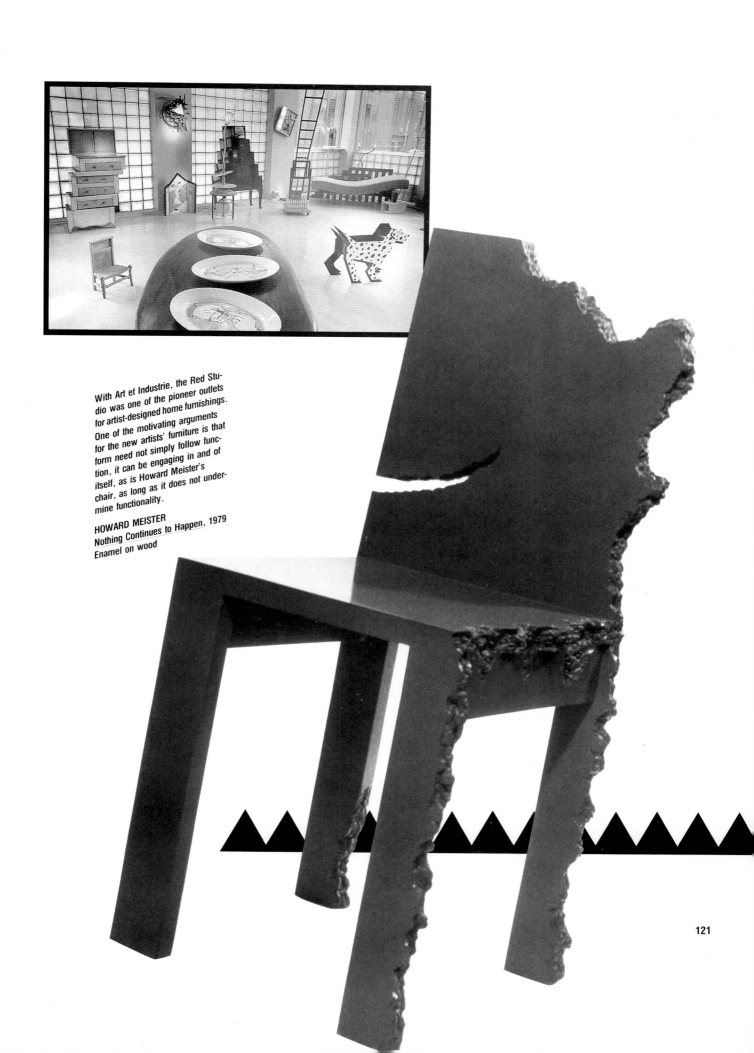

With Art et Industrie, the Red Studio was one of the pioneer outlets for artist-designed home furnishings. One of the motivating arguments for the new artists' furniture is that form need not simply follow function, it can be engaging in and of itself, as is Howard Meister's chair, as long as it does not undermine functionality.

HOWARD MEISTER
Nothing Continues to Happen, 1979
Enamel on wood

121

Released from constraints on their formal imaginations, makers of art furniture blur the real distinction between furniture and sculpture. Among the recurring themes in this latter-day hybrid are whimsy, the freewheeling use of untraditional (often in combination with traditional) materials, and coy or forthright variations on classic designs.

JAMES HONG
Tropic of Cancer, 1981
Wood, steel, glass, cement

CARMEN SPERA
Micheli's Lamp, 1985

STEVE DITCH
Yellow Top Table, 1981

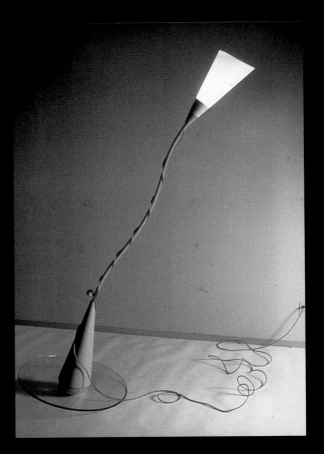

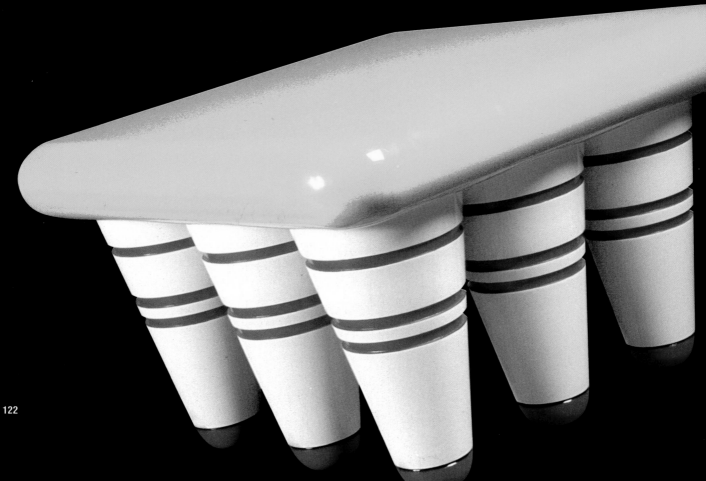

TERENCE MAIN and
LAURA JOHNSON
Queen Anne Queen Anne, 1981
Wood and fabric

MARTIN WONG
Untitled (Cushion Seat), 1985
Acrylic on foam-filled canvas,
65 × 68 × 6"

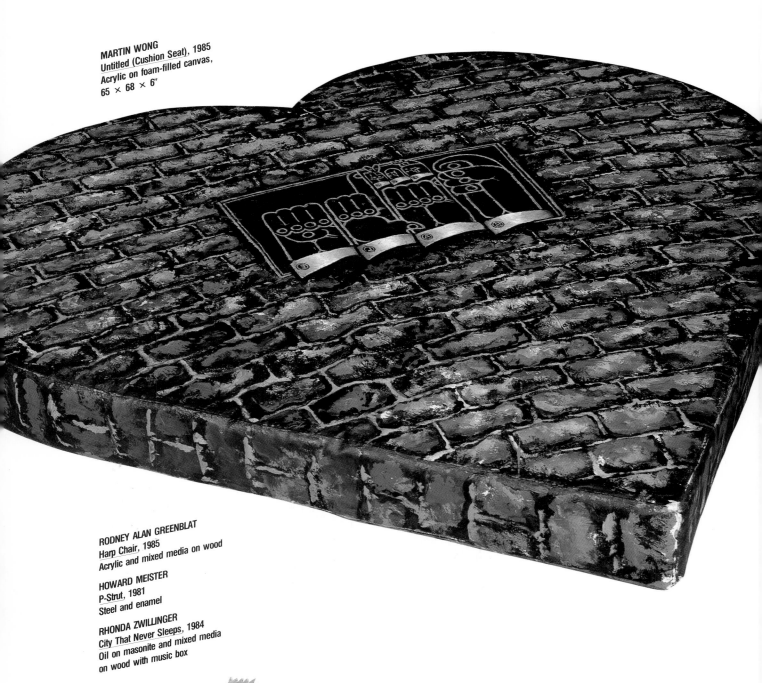

RODNEY ALAN GREENBLAT
Harp Chair, 1985
Acrylic and mixed media on wood

HOWARD MEISTER
P-Strut, 1981
Steel and enamel

RHONDA ZWILLINGER
City That Never Sleeps, 1984
Oil on masonite and mixed media
on wood with music box

124

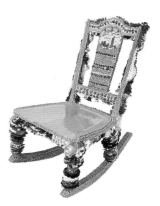

The addition of functional concerns to aesthetic ones marks a clear distinction between '80s Funarturists and predecessors such as Richard Artschwager and Scott Burton. The Cadillac Chair of Michael McDonough, for example, is a playful variation of the stuffed armchair, as pleasing to the derriere as it is to the eye, while Burton's granite chaise longue is highly polished, sharply honed at its bends, and cold as—well, stone. In Burton's case, the functional aspect is incidental to the sculptural form. Of course, Burton is a bit older than McDonough and maintains a certain modernist allegiance to art for art's sake. McDonough is more concerned with function and with eliciting at least a little bit of post-Pop humor. Burton makes a sculpture of a chair, whereas McDonough makes a chair out of a sculpture. A similar shift in strategy marks many of the '80s artists working in the new Funarture movement.

The customizing impulses of the Fun aesthetic add a twist to this strategy. These artists begin with functional objects—toasters, cars, telephones, and just about any other mass-produced item you can think of—and turn them into art while keeping the objects' functional design intact and in working order. The idea isn't to take objects out of their pragmatic contexts but rather to insert an aesthetic dimension into those contexts. "You have to have furniture anyway," observes Rodney Alan Greenblat, "so why not have fun stuff?"

Customizing, as practiced by the likes of Greenblat, Haring, Sharf, and Zwillinger, is now a thriving art cottage industry, producing a highly diverse mix of products that range from the useful to the what-the-hell-is-that, from little toys and trinkets to monumental objects like Zwillinger's Liberace-esque piano, Sharf's Cadillac, and Eric Stoller's lightmobiles. As customized objects have grown in number and kind so have the outlets in which they can be bought. The Gracie Mansion Gallery, which shows "art," has a separate outlet, the Gracie Mansion Museum Store, where "objects" by the same artists can be purchased. Other galleries now sell objects in various price ranges and often find themselves in competition with jewelry shops and boutiques.

Artist-designed furniture and customized objects draw much of their appeal from the personal, often idiosyncratic, aura they give to a world filled with anonymous mass-produced gadgets. But the success with which these art objects are being met in the marketplace has

Two early landmarks in the current wave of artists' furniture contrast forcefully in spirit. Scott Burton's granite chaise longue minimizes form so severely that function seems also to be reduced while Michael McDonough's plush Cadillac Chair veers away from purely functional lines with its allusions to automobiles.

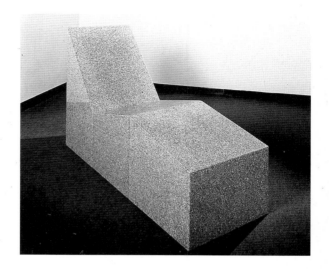

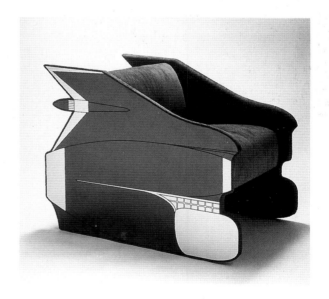

SCOTT BURTON
Chaise Longue, 1983
Granite, 41½ x 24 x 67"

MICHAEL McDONOUGH
Cadillac Chair, 1977

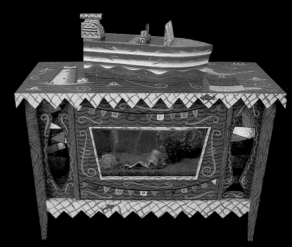

RODNEY ALAN GREENBLAT
Boat Box, 1985
Mixed media, 10 x 26½ x 6¾"

The Something Palace, 1984
Acrylic on wood and museum
board, 6 x 4½ x 10"

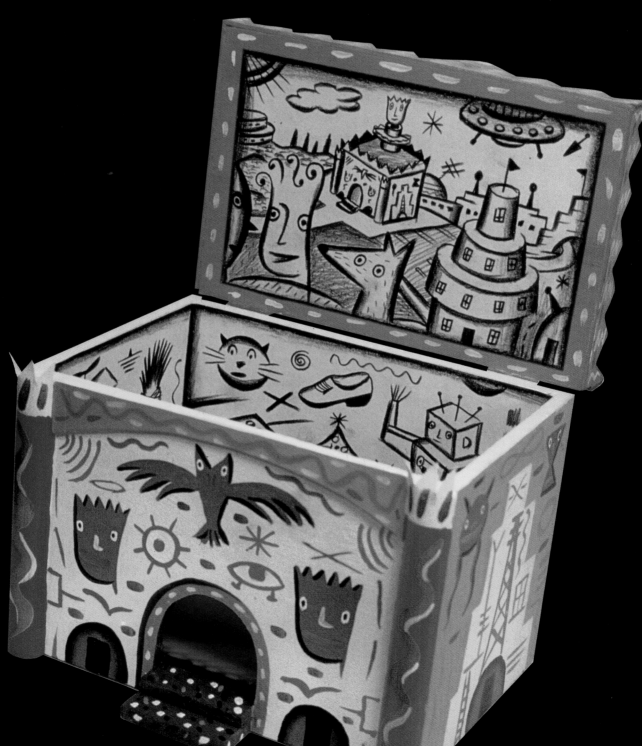

126

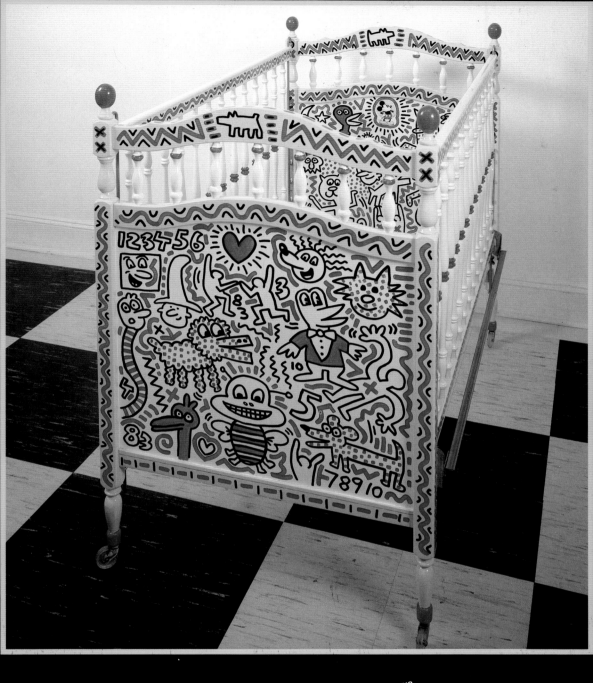

KEITH HARING
Untitled, 1983
Enamel paint on crib

RODNEY ALAN GREENBLAT
Red-Legged Dabriolet, 1984
Acrylic on wood,
$30^{1}/_{2}$ x $40^{1}/_{2}$ x $20^{1}/_{2}$"

E.B. JACKSON
Burst!, 1982
Tufted wool

CARMEN SPERA
Table Mirror, 1983
Glass, wood, enamel

TERENCE MAIN
Crystal Needle, 1986
Glass and concrete

128

inspired some '80s artists to foray even further into areas that used to be off-limits to artists: marketing and mass production.

Looking back, the manufacturing gestures of Colab artists—Tom Otterness's plaster objects and Judy Rifka's sheets, for example—seem primitive. By 1985 Dan Friedman, Keith Haring, Jenny Holzer, and Barbara Kruger, among others, had produced T-shirts for Willi Smith, a fashion designer who distributed them nationally. Sharf has manufactured his own line of fabrics in twenty-two colorful patterns, while Mark Kostabi designed a shopping bag for Bloomingdale's department store, as well as a line of jewelry, baseball caps, jackets, books, and his ever-present postcards. Not to be outdone, Haring opened his own retail store, the Pop Shop, which sells his buttons, shirts, puzzles, radios, posters, postcards, jackets, blowup toys, and other souvenirs of the art world, which fit neatly into his own plastic shopping bag, available for two dollars plus tax.

Although the scale and materials are different, the production of multiple art objects is akin to making a silkscreen, lithograph, or poster from a painting: it requires technical skills to translate the master or prototype into a copy that retains the integrity of the original. "There's a huge difference," summarizes Ronald Feldman, whose gallery represents the work of Mark Kostabi as well as prints by Warhol, "between a reproduction rip-off and an artist's working with the technicians to solve the design problems of manufacture." With careful work and patience these problems can be solved, as two recent manufacturing successes from the design world demonstrate: James Evanson's lamps and Michael Graves's teakettle. Evanson sold more lamps in twelve months than he had in his ten-year career; Graves's teakettle is nearing sales of one hundred thousand at a retail price of $99.95.

Reflecting on the current downtown art scene, Feldman looks toward the future: "The new generation of artists is going further into commercial ventures than previous generations. If they can remain true to themselves, they will not only penetrate deeper into society at large but will also bring up many interesting questions about art and design."

In a 1984 manifesto entitled "New Space," Kaufmann described his vision of this marriage of art and design as "function following form, content over style, style over styles

Whether making furniture or wearable art, artists currently involved with designing utilitarian objects often go to great lengths to prove that unlikely materials are perfectly usable.

ALEX LOCADIA
Concrete Wristwatch, 1986
Concrete, vinyl, watchparts

JAMES HONG
Vessel, 1983
Lacquered aluminum

Rhonda Zwillinger is probably the New York art world's most dedicated and extravagant customizer. She festoons almost anything she can get her hands on, from her own shoes to baby grands, with shards of mirror and glass, costume jewelry, and just about every other substance that glitters but is not gold (although it might be gold leaf).

RHONDA ZWILLINGER
Toute de Suite, 1985
Oil on masonite, candelabra, mixed media on piano

Sunset Sonata, 1984
Mixed media, 50 x 35 x 35"

A bevy of heavy-duty beauties from the East Village model Keiko Bonk's clothing. Below: The painter-designer herself sits in the window of her gallery, Piezo Electric, with Piezo codirector Douglas Milford in attendance.

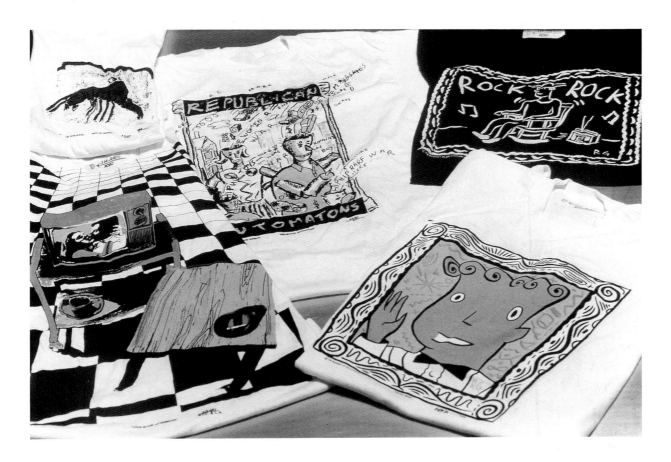

exploring and combining natural and unnatural materials, reinventing form and structure, and making objects for the mind as well as the body, and the spirit as well as the mind."

Whether one calls this work art, design, commodities, or simply things, its makers are satisfied to draw on its hybrid durability and potency. "We must be farsighted enough," concludes Kaufmann, "to approach the present with designs on the future. Realistically, there are only two ways of changing yourself and the quality of your life: heredity and your environment. Since the first one is out, we feel that these objects address themselves fundamentally to the only way we the living have of bettering our lives."

In its own, more limited context, wearable art can get even more extreme and unlikely than artists' furniture. T-shirts are in themselves nothing surprising, but in artists' hands they can be startling works of seen-in-the-street art, like graffiti on people rather than on walls. Here, T-shirts by Greenblat, David Sandlin, and the Marilyn Minter Christof Kohlhofer team, sold in the Gracie Mansion Gallery store.

Gracie Mansion and
Sur Rodney Sur.

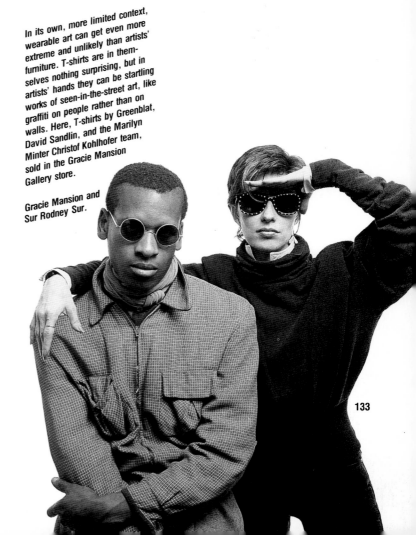

133

"There are some artists out there
with intense media images,"
David Wojnarowicz observes with
a shrug. "If that's what they want
that's what they deserve. Person-
ally, I was never very social."
Wojnarowicz thus takes a dim
view of the commercialization of
art and artists—and pieces like
Tuna, however redolent of 1960s
Pop Art, reflect his disdain.

DAVID WOJNAROWICZ
Tuna, 1983
Acrylic and collage on paper,
30 x 20"

GOODS

When Robert Longo came to New York in the late '70s, the idea of a young artist making money from his work was hard to imagine, and even if some ambitious soul had thoughts in that direction, the small, closed world of the SoHo gallery system hardly favored his chances. A decade later, all that has changed. What is called the "East Village scene" has witnessed the opening of hundreds of new galleries, shops for artists' objects and furniture, commissions from nightclubs, major department stores, and nationally distributed designers, artists engaged in marketing and mass production, and, overall, a pervasive spirit of entrepreneurism in the art world.

Looking back over the early days of the East Village art scene, circa 1982, Gracie Mansion, *grande dame* of the new art dealers, recalls: "One could—and did—open a gallery with no money or art world connections. In fact, if I had known anything about business or the art world, I would never have opened. Thank God I was naive." But Mansion was more than naive. As an art student in Newark, she was prompted by her teacher, Happenings artist Al Hansen, to do something zany and devil-may-care in and around art, and the first art enterprise of the former Joanne Mayhew Young may have seemed at the time more like a collaborative performance or conceptual installation piece than the propitious begin-

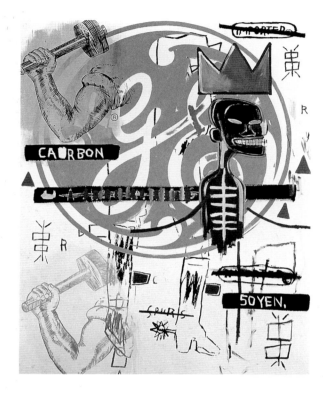

JEAN-MICHEL BASQUIAT
and ANDY WARHOL
Untitled, 1984
Acrylic, oil, and silkscreen on
canvas, 86 x 68"

ning of a real business. In March 1982, funded
by her two-hundred-dollar tax return, Man-
sion opened a gallery. Calling it the Loo
Division (it was located in her bathroom), she
sponsored three exhibitions. The last was a
Stephen Lack show which, thanks to a blurb
in the *New York Post*, got more attention than
the loo could handle.

Although Mansion had come to New York
to be an artist, the unexpected social and me-
dia success of the Loo Division inspired her to
open a gallery with—as opposed to in—a
bathroom. The tax return was long spent, so
the question became, Who would finance an
art gallery in a drug- and crime-infested slum?

Mansion found an initial investor who
"agreed to put up twenty-five thousand dollars
in exchange for all the profits from the gal-
lery, forever." Whatever these arrangements
lacked in fairness or business acumen became
irrelevant when the investor backed out, leav-
ing Mansion broke and with business rent to
cover. Miracles have a way of happening to
the naive, however, and Mansion's appeared
in the person of Jim Stark, an attorney who
put up four thousand dollars with no strings
attached. Mansion repaid Stark with art, and
for the first six months of the gallery's exist-
ence, he had the honor of being her only
collector. "I'm not independently wealthy, or
even dependently wealthy," Stark says with a
shrug, "so four thousand dollars represented a
big investment to me at that time. It's easy to
look now and say, 'Hey, he got Greenblats and
Wojnarowiczs for next to nothing,' but at that
time those artists were totally unknown. Hon-
estly, I never thought of the art as investment
or dreamt that it could increase in value. I did
it for grins and because, well, I liked Gracie."

Success later prompted Mansion to take a
partner, Sur Rodney Sur, a similarly adventur-
ous soul who had done things like running a
gallery in an animal hospital and cohosting a
cable TV talk show with his dog Niffty Nipper-
pits. Sur, whose advice to artists is to "be
polite, be patient, and, most important, keep
working," has a mild-mannered directness
that was the perfect complement to Mansion's
spirited frivolity, and the creative combination
of the two made their gallery an important
nucleus for downtown art. Their theme
shows—such as *The Couch Show,* in which
artists made couches to exhibit under their
paintings, and *The Famous Show,* in which
soon-to-be-famous artists exhibited portraits of
the already famous—attracted the media and

collectors long before Mansion's artists had the benefit of being well known.

If Mansion had a model, it was Fun Gallery, the first gallery in the '80s East Village, which had been set up with initial financial backing of just under five hundred dollars (another tax return). "Kenny Scharf named the gallery, which was nameless until our third show," says Bill Stelling, who co-owned Fun with Patti Astor. Astor, a platinum blonde and former underground film star, met an impressive group of graffiti writers through her role in Charlie Ahearn's *Wild Style*. With these connections, Fun was able to mount early shows of Jean-Michel Basquiat, Jane Dickson, Crash, and Futura as well as Kenny Scharf.

Although Fun did not weather the tide of mid-'80s rent increases, the Gracie Mansion Gallery now occupies a relatively spacious storefront on Avenue A and counts Rodney Alan Greenblat, David Wojnarowicz, Rhonda Zwillinger, and Mike Bidlo among its artists. Over a four-year span, typical prices have shot up an average of 50 percent a year. Bidlo's Brancusi-head multiple zoomed from one hundred dollars to one thousand dollars in little over a year, while one Greenblat chair, sold for a few hundred dollars in 1983, fetched nearly four thousand dollars three years later.

Another dealer who began as an artist is Tony Shafrazi. Born in Iran, educated as an artist in London, Shafrazi was no stranger to the New York art world. In fact, his notoriety was such that many scene-watchers were startled when he opened his original gallery, actually in his apartment on Lexington Avenue in midtown Manhattan. They predicted he wouldn't last the year.

A decade earlier, Shafrazi had been an earnest, even fanatical follower of philosopher—conceptual artist Ian Wilson, attending Wilson's neo-Platonist discussions on the nature of existence and participating eagerly, sometimes agitatedly. Shafrazi's intensity finally led him to guerrilla action: spray-painting the declaration "Kill Lies All Lies"— right on Picasso's *Guernica* in the Museum of Modern Art. This early, radical bit of graffiti-performance got Shafrazi plenty of attention. It also got him a police record and the undying enmity of the museum.

After that, Shafrazi dropped out of sight for a while, then resurfaced as an underground filmmaker in the Jack Smith tradition.

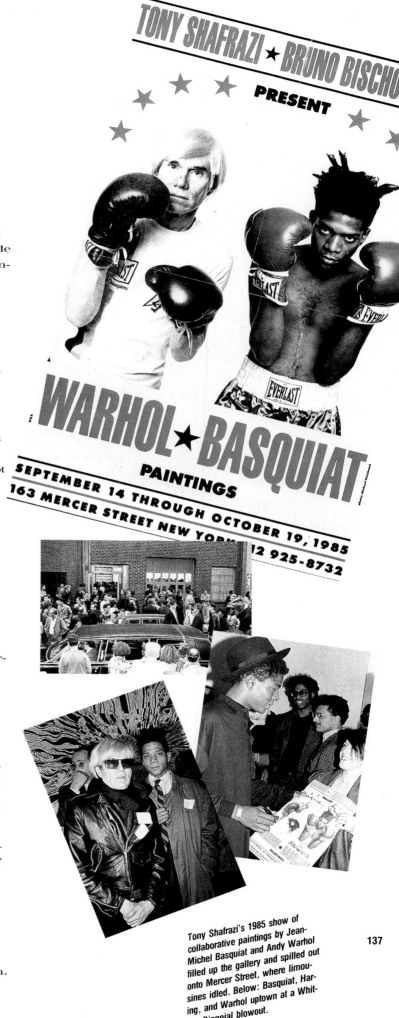

Tony Shafrazi's 1985 show of collaborative paintings by Jean-Michel Basquiat and Andy Warhol filled up the gallery and spilled out onto Mercer Street, where limousines idled. Below: Basquiat, Harring, and Warhol uptown at a Whitney Biennial blowout.

137

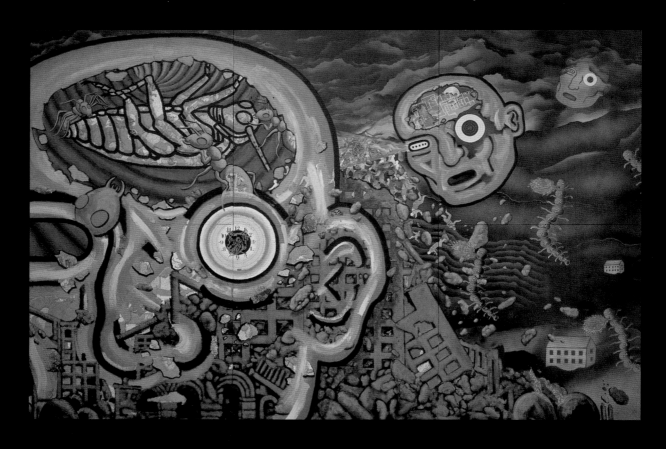

DAVID WOJNAROWICZ
Invasion of the Alien Minds, 1984
Mixed media on masonite,
96 × 120″

Untitled (Burning Child), 1984
Acrylic and map collage with
mixed media on fiberglass,
49 x 24 x 15″

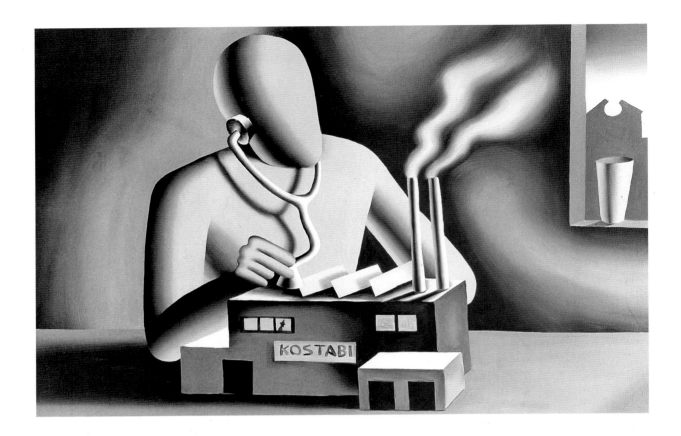

Kostabi's one-man art factory churns out pictures at a remarkable rate, about rivaling that of Warhol's own Factory. Kostabi's paintings of factories can thus be understood in part as self-parodies. The title, a typical South Bronx salutation, reflects the fact that a print of this painting was included in a portfolio published as a fund-raising device by Fashion Moda.

MARK KOSTABI
Yo Kostabi, 1985
Oil on canvas, 48 x 72"

The decadent opulence of Shafrazi's film (and accompanying book) *Mogambo* was as far removed from the heady severity of his former attitude as could be imagined. Next thing people knew, the concept-artist-turned-vandal-turned-cineaste had opened a gallery. Moreover, in his gallery Shafrazi was exhibiting longtime conceptualists and postconceptualists like Olivier Mosset, Sarah Charlesworth, and Zadik Zadikian, along with more frequently exhibited artists like Keith Sonnier.

Among the assistants Shafrazi hired to do everything from paperwork to gofer work at the gallery was a student of Sonnier's at the School of Visual Arts named Keith Haring. By the time Shafrazi finally got Haring to show him his work, the gallery had gone public in a converted SoHo garage and had begun to show younger artists. Shafrazi, knowing of Haring's literally underground reputation and recognizing that his style was distinctive yet instantly appealing, asked him to show. The rest is one of the nicer success stories of the decade. "To give you an idea of how much the work has come around," says Shafrazi, "consider that for Keith's last show I bought advertising space in the subways—on the same display spaces that Keith used to draw."

MARK KOSTABI
Upheaval, 1984
Oil on canvas, 96 x 72"

Materialism, 1982
Oil on canvas, 48 x 36"

Bed of Nails, 1983
Oil on canvas, 72 x 52"

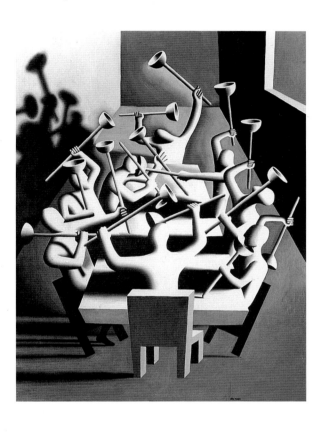

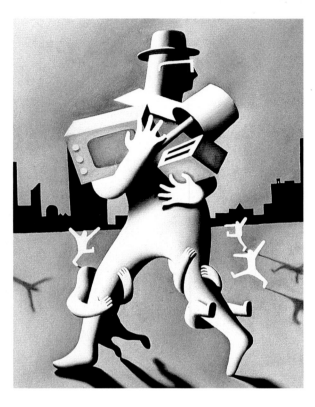

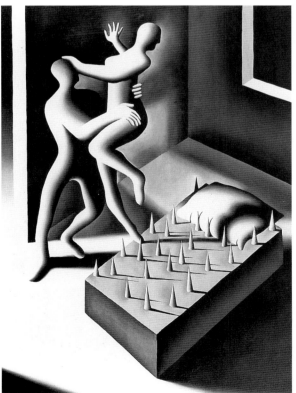

"I use drawings as a way of finding ideas," Kostabi explains. "I don't edit my thinking or worry about what I might quickly sketch. I turn the best sketches into finished drawings and the best drawings become paintings." Among his inspirations are Materialism, a comment on art, and artists, which can be bought and sold like used cars or pork belly futures, and Upheaval, a boardroom scene whose executive everymen brandish the plungers with which they plan to "flush" one another's brains.

MARK KOSTABI
The History of Architecture
Descending a Staircase, 1986
Oil on canvas, 90 x 68"

The precarious positions Kostabi's everymen find themselves in comment obliquely on inner, personal anguish and outer, social conflicts. His urbane capitalism is tinged with more than a trace of existential despair—as the Organization-Man hustle of the '50s was, and as the yuppie rat race is coming to be. Kostabi's figures are often seen from an extreme angle, imparting the subjects' own vertigo.

Dealing with Mr. Know-It-All, 1986
Oil on canvas, 90 x 136"

Vision, 1986
Oil on canvas, 68 × 48"

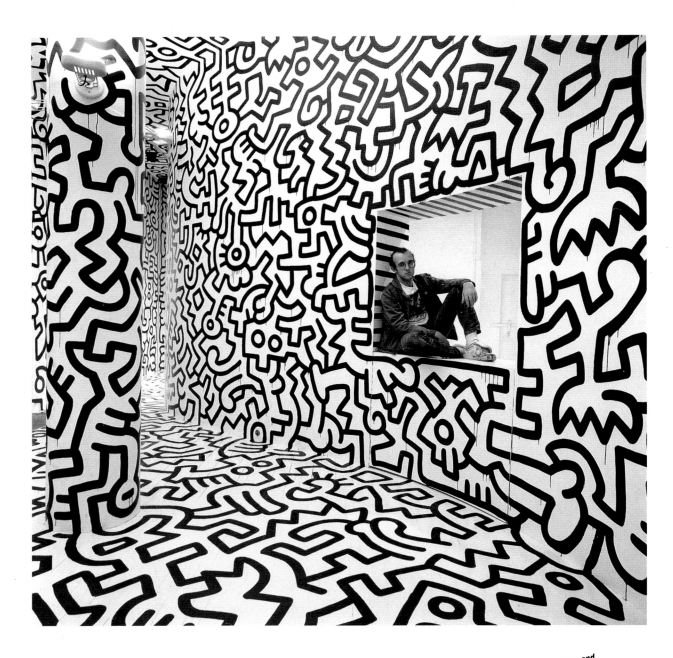

Art shops, featuring notions and knickknacks of widely varying styles, functions, and prices, have begun to spring up in Lower Manhattan. The East Village boasts the Gracie Mansion store, the 5 & Dime with its quirky items, and the slightly more crafts-oriented Civilization, while on the lip of SoHo stands the Pop Shop, where only items designed (or drawn on) by Keith Haring and his friends can be acquired. Here Haring sits in an environment of his own making.

The initial successes of dealers like Mansion, Astor, and Shafrazi had less to do with capital than with the variety of features that characterized the art scene in the early '80s: a flair for performance, cheap rents, the social networks developing in the clubs, and a large number of artists who were fed up with SoHo and willing to show just about anywhere. But money quickly turned the fun of the early East Village scene into serious business.

Corporate collection buying by the likes of IBM, Philip Morris, Citibank, and Chase Manhattan has accounted for the largest share. But a number of private individuals, some new to the collecting game and some old hands, have also committed themselves to the current generation of artists. One of the earliest collectors of the work of young downtown artists like Greenblat and Zwillinger was Bodi, a well-known commercial photographer. "I simply love the work," Bodi says, his electric environment contrasting with his own quiet manner. "I became so obsessed with the collecting that I found myself constantly running out of my studio, driving around to see what was new, even at the expense of my business at times." Like many of the early collectors, Bodi has integrated this work into his lifestyle, so much so that the thought of selling the work he has collected, even at enormous profits, seems painful.

"Whenever a client asks me if art is a good investment," says Jack Boulton, Adviser on the Arts at Chase Manhattan Bank, "I tell them quite simply no. One doesn't—or shouldn't—buy art to make a killing or as a hedge against inflation. Invariably, investors with that attitude are looking to buy and sell, which is not a good way to amass an art collection. For instance, if you buy two paintings for five thousand dollars, and six years later one is worth seventy-five dollars and the other worth seventy-five thousand dollars, which one should you sell? The answer is, unlike any other investment, you keep the expensive one and dispense with the other as quietly as you can. Strange way to look at an investment." Boulton adds, though, that his purchases have "increased in value about twenty-five to thirty percent every two years."

What has made the work of this generation of artists so attractive to the market? Shafrazi discounts the role of critics, noting that they "have given no clues as to what the young artists are about. The work has authen-

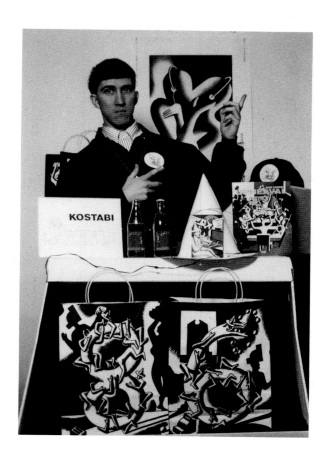

Part social commentator, part wiseguy philosopher, and partly a self-created parody of the ambitious artist, Mark Kostabi has already begun to garner the kind of popularity Keith Haring enjoys. Here Kostabi poses with some of his fabrications, including a shopping bag designed for Bloomingdale's.

ticated itself." In contrast to minimalist and conceptualist movements of the '70s, which gave the viewer much to think over but little to look at, the styles of the new generation of artists are direct, personal, iconographic, and above all accessible. If these artists often engage in criticism of the mass media, they do so by using that media's own tools and tricks—eye-catching colors, simple images, and entertaining narratives—with similar success.

Mark Kostabi's work exemplifies the tensions felt by artists whose work is at once commercial and about commercialism. His canvases depict faceless, sexless executives endlessly competing for some mythical success and have captured the yuppie spirit both comically and tragically. He often clothes his otherwise featureless beings in telling garb—pointed hats, for instance, suggesting at once witches' and dunces' caps. Still, there is an element of compassion in Kostabi's art and in his public persona. Like a smart-aleck adoles-

145

SCOT BOROFSKY
Guardian of the Mountain, 1986
Enamel on canvas, 66 x 48"

cent, though not unwittingly, Kostabi reveals and even broadcasts his vulnerability in his very stance.

Many of Kostabi's collectors hail from the highest ranks of the executive positions he has so ruthlessly portrayed. Early "Kostabites," as he refers to his collectors and coterie, included Hollywood producers Ray Stark, Daniel Melnick, Aaron Spelling, and Norman Lear, who all followed the lead of fellow producer and collector Rodney Sheldon. "Money sums up the art world perfectly," Kostabi says with a shrug. "That's what people want me to say because they assume I'm money motivated and I let them assume that. The fact is I go with my intuitions and impulses and try to have fun. If you work hard and do what you want, the logical result is quality and people will always pay for quality—so money just comes."

Jeffrey Deitch, art investment adviser to Citibank, suggests that Andy Warhol "reinvented the idea of what it means to be an artist, which is far more powerful than creating a new art movement." Warhol's "steal it from the media, push it in the media, and sell it at a high price" formula is birthright to this generation of artists. For Kostabi, an uptown visit means not only a sale to a few

collectors and the Museum of Modern Art but a side job designing bags and products for Bloomingdale's as well. "Marketing is a rest from painting," he has written, "and painting is a rest from marketing."

Even as Kostabi markets, rests, paints, and markets again, and as each cycle creates better product—more of it and at higher prices at each turn—some artists are questioning the wisdom of this new entrepreneurial aesthetic. Multimedia artist David Wojnarowicz is a case in point. A street kid who ran away from home at an early age, Wojnarowicz creates work with a hard, violent edge that is not likely headed for mass-market consumption. Though he now makes a living solely from his artwork, his entrance to the gallery scene in 1980 came in the form of an impromptu, unrequested show at the Leo Castelli gallery. Wojnarowicz and a friend made what he calls an "action installation" in Castelli's stairway comprised of bloody cow bones, a plate, a knife, a fork, and spray paintings of bombers and burning buildings.

Wojnarowicz's Castelli installation went unremarked, but during the next few years his various renderings of skulls, maps, wordplays, and homosexuality became hard-core East Village archetypes. With sold-out one-man shows at Gracie Mansion and exhibitions in Europe, he has attained success of a sort. Nonetheless, he wonders whether the artists who are moving toward commercial acceptance will be able to retain their integrity and a living relation to the sources of their inspiration. "The energy I felt here in the beginning is dissipating," he says of the East Village scene. "The mix of people, even the violent edge to some areas of town, was the stuff I was working with. Wall-to-wall sushi joints just aren't inspiring at all."

Wojnarowicz's Neo-Punk art is not the only movement that is developing outside the media sweepstakes. Scot Borofsky, who likes to think of himself as a neo-primitive, sprays, scrawls, and stencils his compelling symbology on the urban ruins of the Lower East Side, then works the most successful of those images onto canvas. In that sense, he has taken a page from Keith Haring's notebook, using the outdoors as both a message board and an experimental sketchbook. But whereas Haring's stark subway imagery lashed out at contemporary issues with an army of radiant children and exploding television sets, Borofsky's iconography has a meditative quality suggesting

Scot Borofsky, who paints his
hieroglyphic images as frequently on
the walls of the Lower East Side
as he does on the canvas, is a
throwback to those thrilling days of
yesteryear, when artists were ded-
icated to making the art they had
to make, not in simply having to
make it in the art world. The
spray-paint colors give Borofsky's
work a very contemporary immedi-
acy, but the drawn figures often
seem as if they were simplifica-
tions of Aztec and Mayan ruins.

SCOT BOROFSKY
The Messenger, 1985
Enamel on canvas, 68 x 44″

147

The Collectors

1 Donald Rubell
2 Martin Sklar
3 Elaine (and Werner) Dannheiser
4 Eugene Schwartz
5 Adrian Mnuchin
6 Hubert Neumann
7 Mera Rubell
8 Martin Margulies
9 Jerry Spiegel
10 Barbara Schwartz
11 Dolores Neumann
12 Herbert Schorr
13 Lenore Schorr
14 Emily Spiegel

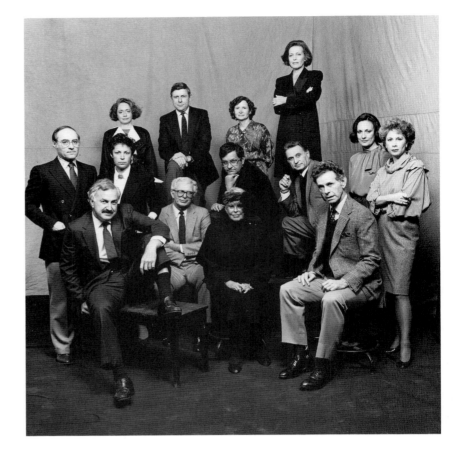

Dealers 1

1 Doug Milford
2 Patti Astor
3 Nina Seigenfeld
4 Alan Belcher
5 Peter Nagy
6 Elizabeth McDonald
7 Bill Stelling
8 Sur Rodney Sur
9 Mario Fernandez
10 Alan Barrows
11 Dean Savard
12 Rich Colicchio
13 Gracie Mansion

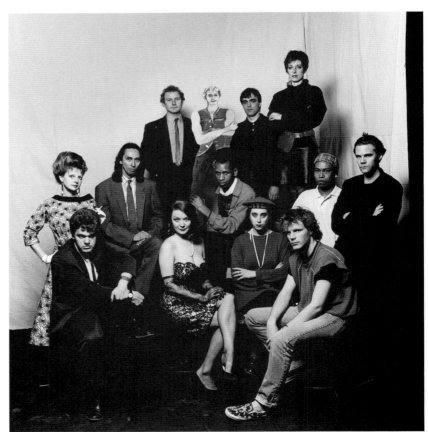

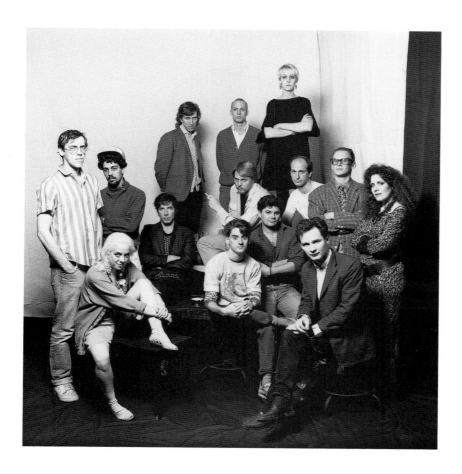

Artists 1

1 Judy Glantzman
2 Rodney Greenblat
3 Richard Hambleton
4 Stephen Lack
5 Joseph Nechvatal
6 David Wojnarowicz
7 Futura 2000
8 Mike Bidlo
9 Luis Frangella
10 Arch Connelly
11 Rhonda Zwillinger
12 Mark Kostabi
13 Craig Coleman
14 Greer Lankton

For an article by Robert Pincus-Witten for Arts Magazine, Timothy Greenfield-Sanders photographed several groups of those cited by Pincus-Witten, or others, as the downtown art movers and shakers. Stealing a beat from Mike Bidlo, Greenfield-Sanders "appropriated" the setup of the famous group portrait "The Irascibles," the 1951 assembly of Abstract Expressionists. This time, however, Greenfield-Sanders created several such group shots, including these of the southern Manhattan money-wielders, the dealers and collectors. Line drawings by Mark Kostabi.

TIMOTHY GREENFIELD-SANDERS
The Collectors, Dealers 1,
Artists 1, 1985
Black-and-white photographs,
13 × 13"

that individual wholeness and nature itself are of more fundamental concern than political or economic issues. It seems logical that the overflow of art aimed at or ignited by yuppie materialism, art that could "cash in on passion" as Kostabi puts it, would eventually spur a more spiritual movement.

Robert Longo likes to call art history a weapon for artists to use. If it is, the art of the mass-media generation must have some application for the next generation of artists as they, in turn, attempt to conquer new markets. Perhaps the new herald of art as commerce will only elevate the quality of the work that is made under its banner, even if that work cashes in on spirit rather than Kostabi's passion. Can fine art foray into the mass market without being consumed by it? "It's great that artists are for the first time actually making money," concedes Longo. "But, on the other hand, it scares me to think that the art that sells well will be the art that's revered."

RONNIE CUTRONE
The Love of Money, 1985
Acrylic on canvas, 108 x 84″

Money makes the world go 'round,
and no place is spinning faster
than the downtown art scene. Here
Mark Kostabi strikes a pose as St.
Market, green halo and all.

THANKS

The authors would like to express their sincere thanks to Artists Space, John Ashbery, Jeffrey Deitch, Ronald Feldman, Gracie Mansion, Metro Pictures, Dolores Neumann, Hubert Neumann, James Poppitz, and Andy Warhol, all of whom helped us, above and beyond the call of duty, to separate the Art Hearsay from Art History.

Special thanks go to Charlie Ahearn, John Ahearn, Brooke Alexander, Baskerville & Watson, Steve and Marsha Berini, Mike Bidlo, BlumHelman Gallery, Bodi, Mary Boone Gallery, Scot Borofsky, Jack Boulton, Martin Burgoyne, Leo Castelli, Chae, Henry Chalfant, Civilian Warfare, Michael Clark, Paula Cooper, Crash [John Matos], Ronnie Cutrone, Peggy Cyphers, Daze [Chris Ellis], James Evanson, Jim Fouratt, Gallery 91, Barbara Gladstone, Rodney Alan Greenblat, Richard Hambleton, Keith Haring, Alanna Heiss, Jenny Holzer, James Hong, International with Monument, Elizabeth Jackson, Mark Kostabi, Stephen Lack, L.D. Lawrence, Limbo Gallery, Katie Little, Robert Longo, Ann Magnuson, Terrence Main, Merrill & Pierce, Frosty Meyers, Moke Mokotoff, Nature Morte, Tom Norman, Anninna Nosei, Tom Otterness, Piezo Electric, PPOW, Rick Prol, Dianne Radler, Kenny Scharf, Semaphore Gallery, Huck Snyder, Carmen Spera, Ed Tomney,

153

Rigoberto Torres, Anton Van Dalen, David Wojnarowicz, and Rhonda Zwillinger. We also extend our thanks to the other artists, critics, curators, collectors, gallery owners, and researchers who contributed to these pages and without whose help this book would not have been possible. Finally, and as proverbially not least, we wish to specially thank our editor Sharon Gallagher who worked at least as hard as we did to make this book possible. Also we owe thanks to Steve Neumann who coordinated the research to the design and to our wives—Jack Ox, and Deborah Frichman-McKenzie—for encouraging us through the years.

Photographs reproduced in this book were supplied through the courtesy of the individuals and institutions listed below, to whom we owe special acknowledgment and thanks. Copyright in these images, and all rights, renewals, and extensions thereof, are reserved by the copyright owner.

ABC No Rio: 33.
Adam: 8 top left, 44, 61.
Charlie Ahearn: 46.
Brooke Alexander: 26, 27, 32, 34, 35.
Area: 70, 71 center and bottom.
Joey Arias: 82 film strip.
Art et Industrie: 120 top and bottom, 121, 122–23, 124 top and bottom center, 128 top, bottom left, bottom right.
Arts Dolores Ormandy Neumann: 54 bottom left.
Baskerville and Watson: 91 bottom left and right.
Mike Bidlo: 8, 86, 94 top and center, 95, 96.
Bruno Bischofberger: 136.
Mr. and Mrs. R. Black: 106 bottom.
Diane Brown Gallery: 90.
Andrea Callard: 29 bottom, 30.
Henry Chalfant/Martha Cooper: 47 top, center, and bottom.
Tseng Kwong Chi: 52, 53, 98, 103 bottom, 115 top right, 144.
Chinitz: 132 top.
Michael Clark: 115 top left.
Martha Cooper: 38 bottom.
Paula Court: 12, 16, 64 top, 76, 78 top, 79 right, 80 bottom, 81, 83 bottom left and right, 85 bottom, 121 top, 132 bottom, 137 bottom.

Ronnie Cutrone: 64.
Peggy Cyphers: 113 top.
Fashion Moda: 38–39 top.
Ron Feldman Fine Arts: title page, 116, 140–43.
Suzanne Feldman: 100 top.
Deborah Frichman-McKenzie: 112.
Dan Friedman: 115 top right.
Bobby G.: 33 center.
Galerie Daniel Templon: 110 top and center.
Barbara Gladstone Gallery: 48, 49.
Jack Goldstein: 15.
Lynn Grabowski: 67 top, 71 top, 85 bottom.
Gracie Mansion Gallery: back jacket, 9, 60, 100 bottom, 101 top, 114 top, 115 bottom, 118, 124, bottom left and right, 126 top and bottom, 127 bottom, 131 top and bottom, 133 top and bottom, 134, 138–39, 150 top.
Timothy Greenfield-Sanders, 148–49.
Richard Hambleton: 50.
Keith Haring/Pop Shop: frontispiece, 108–9, 144.
James Hong: 129 bottom.
Rebecca Howland: 40 top.
International with Monument: 88, 89.
Sidney Janis Gallery: 54–55 top, 55.
Lisa Kahane: 28 bottom, 29 top and center, 65 bottom, 97.
Christof Kohlhofer: 34 bottom.
Justin Ladda: 38 bottom.
Gregory Lehmann: 33 top.
Alex Locadia: 129 top.
Michael McDonough: 100 bottom.
Michael McKenzie: 13, 67 bottom, 68, 74, 79 top left, 77, 82 bottom left, 150 bottom.
Metro Pictures: 15, 17, 18, 19, 20, 21, 22, 23, 24, 25.
Metropolitan Museum of Art: 59 bottom.
Mokotoff Gallery: 61 bottom, 146–47.
William Morris Agency: 81 bottom.
Daniel Mularogi: 128 top.
Nature Morte: 90, 91 top.
Anninna Nosei Gallery: 92–93.
Palladium: 62.
Marcuse Pfeifer Gallery: 148–49.
Phillips/Schwab: 94 top and center, 95.
Philip Pocock: 42, 94 bottom.
P.P.O.W: 40 bottom, 113 bottom.
Max Protetch Gallery: 125 top.
Dianne Radler: 69, 72, 80 top.
Salvatore Ala Gallery: 105 top.
Semaphore Gallery: 41, 58–59 top and bottom left, 84, 124 top.
John Sex: 67 bottom.
Tony Shafrazi Gallery: 73, 98, 100 top, 101 bottom, 102–3, 104, 105, 106–7 top, 108

INDEX

(Note: numbers in *italic* refer to illustrations.)

158